IMAGES
of America

THE DELAWARE
AND
RARITAN CANAL

*See you on
the towpath !
Linda Barth*

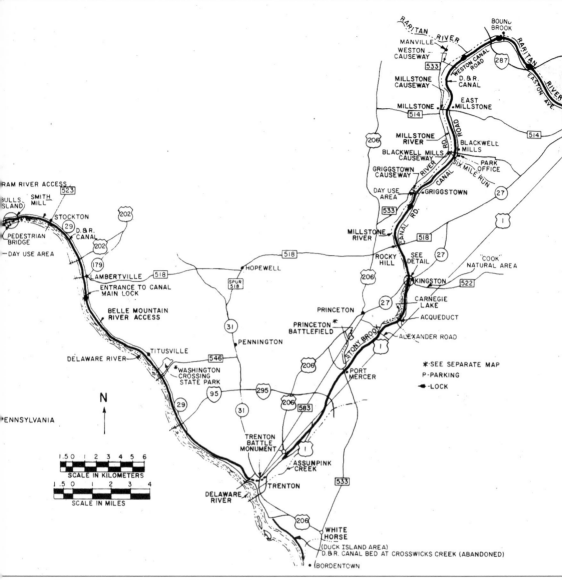

A map of the Delaware and Raritan Canal is shown here.

IMAGES
of America

THE DELAWARE
AND
RARITAN CANAL

Linda J. Barth

ARCADIA

First printed in 2002.

Published by Arcadia Publishing,
an imprint of Tempus Publishing, Inc.
2A Cumberland Street
Charleston, SC 29401

Printed in Great Britain.

Library of Congress Catalog Card Number: 2002107473

For all general information contact Arcadia Publishing at:
Telephone 843-853-2070
Fax 843-853-0044
E-Mail sales@arcadiapublishing.com

For customer service and orders:
Toll-Free 1-888-313-2665

Visit us on the internet at http://www.arcadiapublishing.com

*This book is dedicated to Larry and Kay Pitt and to
Peter and Nancy Vroom, whose love of the Delaware and Raritan
Canal first piqued my interest and inspired me to learn more.*

CONTENTS

ACKNOWLEDGMENTS

This book would not have been possible without the wonderful resources of the Delaware and Raritan Canal Commission. I especially express my gratitude to Jim Amon, the commission's executive director. He generously gave of his time and expertise to help in the selection of images from the commission's photographic archives and provided invaluable assistance to ensure the accuracy of the captions. Thanks also go to Jan Holms and Kathy Wannamacher in the commission office for their help and cooperation.

The Canal Society of New Jersey also opened its archive of Delaware and Raritan Canal photographs to me. I extend special thanks to William J. Moss for his expertise and care in preserving these historic images. He shared with me the Cawley, Crawford, and Austen collections, along with many other photographs and postcards.

Bob Belvin, Randall James, and Monica Eppinger, the outstanding, courteous, and professional reference staff at the New Brunswick Public Library, graciously located many historic and never-before-seen views of the canal in that city.

William J. McKelvey, curator of the New Jersey Transportation Heritage Center and Delaware and Raritan historian, came to my rescue many times, patiently explaining details of the canal structures pictured in many of the photographs.

Gary Kleinedler provided information on the railroad in East Millstone, and Robert von Zumbusch shared with me the history of the Kingston Mill. Thanks also to Richard Hunter for educating me about the Trenton Water Power and to Donald Sayenga for his expertise on the Roebling Works. Thanks to Barbara Ross for advising me on important details.

I am very grateful to historian and author Jim Lee for donating to me his collection of postcards of Delaware and Raritan Canal scenes. Rare and unusual images were borrowed from the Griggstown Historical Society, with the kind help of Nancy and John Allen.

I am deeply indebted to Jim Amon, Bill McKelvey, and Bob Barth for graciously reviewing the text and making valuable suggestions and corrections.

Finally, thanks to my husband, Bob, for his photographic and proofreading skills, his love and understanding, and his patience when my time with him had to be shared with this project.

To learn more about the Delaware and Raritan Canal:

Delaware and Raritan Canal State Park
625 Canal Road
Somerset, New Jersey 08873
732-873-3050
www.dandrcanal.com

D & R Canal Commission
P.O. Box 539
Stockton, New Jersey 08559
609-397-2000
www.dandrcanal.com

Canal Society of New Jersey
P.O. Box 737
Morristown, New Jersey 07963-0737
908-722-9556
www.CanalSocietyNJ.org
(with links to many other canal organizations)

D & R Canal Watch
P.O. Box 2
Rocky Hill, New Jersey 08553
www.canalwatch.org

INTRODUCTION

For centuries, the narrow waist of New Jersey has been a transportation corridor. The Lenape Indians followed trails across the state to harvest seafood along the shore. The earliest stage routes traversed this right-of-way between New York and Philadelphia. Here, too, the Camden & Amboy Railroad first laid its track between Bordentown and South Amboy.

Since this was the flattest and easiest crossing of the Garden State, it was natural that canal supporters proposed this route, too. After several failed attempts, the legislature, on February 4, 1830, finally approved the incorporation of the Delaware and Raritan Canal Company. On the same day, the legislature also granted a charter to the Camden & Amboy Railroad to traverse central New Jersey.

After three days of sales, only 1,134 of the required 5,500 shares of canal stock had been subscribed. The Camden & Amboy, on the other hand, was fully subscribed in 10 minutes. If the remaining Delaware and Raritan stock was not sold within one year, the charter would be void.

To the rescue came Robert Field Stockton of Princeton, a strong supporter of the proposed canal. Stockton persuaded his father-in-law, wealthy Charleston planter John Potter, to provide the funds to buy 4,800 shares, thus validating the charter. A year later, the canal and the railroad merged to form the Joint Companies.

Canal construction began in 1830 under the direction of Chief Engineer Canvass White. When White died in 1834, Ashbel Welch of Lambertville replaced him.

The Delaware and Raritan Canal, a 44-mile waterway, crossed New Jersey, connecting Philadelphia and New York. Since the canal was part of the Intracoastal Waterway along the East Coast, all types of vessels plied its waters. The canal provided them safe passage between the Chesapeake Bay and New England, avoiding the longer, more dangerous journey around Cape May and into the Atlantic Ocean.

Many boats arrived at Lock No. 1, near Bordentown on the Delaware River, via tows from Philadelphia and points south. Traveling north through seven locks, the vessels were lifted 58 feet to the summit, the highest point of the canal, in Trenton. Seven more locks lowered the boats to tidewater at New Brunswick on the Raritan River.

One of the few financially successful towpath canals, the Delaware and Raritan was too small almost from its inception. By the 1850s, Welch was already planning changes. The banks were lined with stone, called riprap, to prevent erosion from the wakes of steam canalboats and tugs. Lock chambers were lengthened from 110 to 220 feet, and the canal was deepened from 6 to 8 feet. An additional lock was built at the outlet in New Brunswick, and in 1868, so-called mechanical mules were installed at all locks on the main canal to speed up the locking process.

The Delaware River is the major source of water for the Delaware and Raritan Canal. At Bulls Island (Raven Rock), a wing dam in the Delaware River diverts water into a 22-mile feeder, dug parallel to the river to supply the main canal in Trenton. This feeder provides enough water to fill most of the canal's 44 miles. In addition to being a water conduit, the feeder was navigable by mule-drawn canalboats as far north as Brookville.

Traffic on the feeder greatly increased after an outlet lock was constructed in the late 1840s, allowing boats to cross the Delaware River from New Hope and enter the Delaware and Raritan at Lambertville. Boats carrying anthracite coal, the canal's chief cargo, left the Pennsylvania coal fields and proceeded south on the Lehigh Canal to Easton. Here, they entered the Delaware Division Canal, continued downstream to the outlet lock below New Hope, crossed the Delaware River on a cable ferry, and accessed the feeder through the outlet lock at Lambertville.

From its opening in 1834, the Delaware and Raritan Canal experienced great success. Due to the Civil War and the ensuing expansion, the 1860s and 1870s were its most profitable years. In fact, in 1866, a record 2.9 million tons were shipped through the waterway—more tonnage than was carried in any single year on the much longer and more famous Erie Canal.

Other goods—such as wire rope, paint, wallpaper, lumber, brick, pharmaceuticals, gin, terra cotta, rock, and farm products—found their way to market via the canal.

The Delaware and Raritan was one of the few canals to use swing bridges, allowing canal vessels and schooners with tall masts to pass through the waterway.

Like other waterways, the Delaware and Raritan had aqueducts, water-filled bridges that carry canals over streams, valleys, railroads, or roads. In Plainsboro, the Millstone Aqueduct conveyed the canal across the Millstone River.

One of the commercially used telegraph systems was installed along the length of the Delaware and Raritan Canal. Employees used it to maintain water levels, report breaks in the bank, and catch boats violating the four-mile-per-hour speed limit.

In 1871, the Pennsylvania Railroad Company leased the Joint Companies for 999 years. From this time, the canal declined steadily and, in 1893, showed a net loss for the first time. It was never operated profitably again. The most important reason for this decline was competition from the railroads, which were much faster, operated day and night, and did not close for the winter.

There also appears to be some truth to the often heard charge that the Pennsylvania Railroad deliberately killed the canal. Repairs became infrequent, and rates were raised for canal users on the very products that received reductions for the railroad users. Thus the railroad, due to its manipulation of rates in its favor and its efficiency, gradually took over more of the shipping.

In the 1920s, as commercial traffic lessened, pleasure boat traffic nearly doubled. Unfortunately, the income from these tolls was not sufficient to overcome the loss of freight traffic. The canal did not reopen in the spring of 1933. In 1936, the Trenton portion of the main canal was deeded to the city and filled in as a Works Progress Administration project. The portion of the main canal in Hamilton Township, south of Trenton, was thereby cut off from the rest of the canal and was abandoned.

The original charter to the Joint Companies called for forfeiture to the state if the canal failed to operate for three consecutive years. As a result, in 1937, with 933 years left on its lease, the Pennsylvania Railroad turned the canal over to the state of New Jersey, which declared it abandoned.

Soon, the canal became a water supply system. Rehabilitation of the main canal and the feeder began in 1944 under the Division of Water Resources. Today, the New Jersey Water Supply Authority maintains and operates the canal as a water supply facility. The authority maintains the culverts, locks, spillways, and other structures to ensure a steady flow of water to its customers. About a million people in central New Jersey have some amount of canal water in their daily supply.

In 1973, the Delaware and Raritan Canal and 17 related structures were placed on the National Register of Historic Places. A year later, in response to pressure from concerned citizens, the legislature created the Delaware and Raritan Canal State Park. The park is owned and operated by the Division of Parks and Forestry, Department of Environmental Protection.

The law creating the park in 1974 also established the Delaware and Raritan Canal Commission, which is charged with four main tasks: to review and approve any state project planned or state permits issued in the park; to prepare and adopt a master plan for the physical development of the park; to produce and administer a plan for the regulation of land use; and to encourage and support local initiatives to complement the park master plan. The Delaware and Raritan Canal Commission is headquartered in the historic Prallsville Mill Complex in Stockton, along the canal feeder.

Today, this truly special park and the historic Delaware and Raritan Canal provide much needed open space for the citizens of central New Jersey. Visitors can hike, jog, canoe, ride horses, cross-country ski, bike, fish, or just walk the dog in this tranquil ribbon of green that connects the flood plain of the Millstone with the foothills of the Watchung Mountains and gives the people of New Jersey a sense of their 19th-century heritage.

One

THE BEGINNING

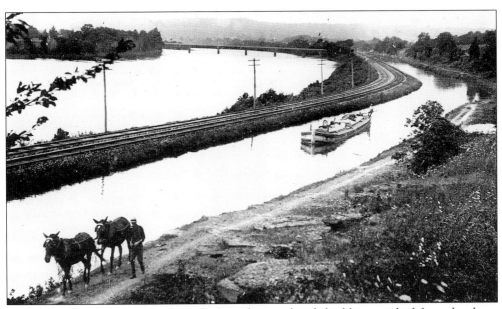

"On deck, after dinner, as the long shadows deepened and the blue vanished from the sky, a procession of coal boats, each with its green light forward, passed silently in review and disappeared around the bend. Against the dark background nothing could be seen of the mules, but in the water, reversed, were their reflections perfectly outlined. As the boats approached they seemed to take on an unusual size, and with it an air of dignity. There was something impressive in their silent, steady advance, as one after another their lights came into view, approached, and passed. The boatmen were silent. The man at the helm, attracted by the unusual illumination . . . in a low tone called his mate, or spoke to his wife and said no more. Wearied with steering all day in the hot sun, and anticipating an all-night's run with a bare chance of hitting the tow at New Brunswick the next morning, the men paid little attention to anything else than the work before them or the necessity of resting while opportunity offered."
—"Snubbin' Thro' Jersey, A Tale of the Delaware & Raritan Canal," *The Century Magazine*, August 1887.

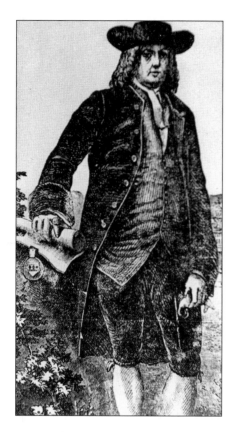

For centuries, the narrow waist of New Jersey has been a transportation corridor, a direct connection between Philadelphia and New York City. Even William Penn (pictured), the founder of Pennsylvania, saw its economic importance. According to William Benedict in 1676, an early chronicler of colonial events, "William Penn . . . gave authority . . . to secure information of one Augustine Heermans, an able surveyor, 'to go up the Delaware River as far as Newcastle or farther, as far as vessels of 100 tons could go; as we intend to have a way cut across the country to Sandy Hook.'" Although no written report has ever been found, the idea nevertheless had merit and would recur in the ensuing centuries.

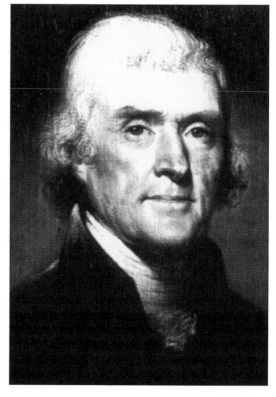

On March 2, 1807, Pres. Thomas Jefferson (pictured) commissioned Albert Gallatin, his secretary of the treasury, to survey the public works then existing in the country "and name such as were worthy of government aid." In just over a year, Gallatin completed his masterful work and sent it to the U.S. Senate. His conclusions were that "good roads and canals" would facilitate commerce and unite the most remote sections of the United States. His first idea was to improve inland navigation from Massachusetts to Georgia via great canals along the Atlantic seacoast, with one canal cutting across New Jersey between the Raritan and Delaware Rivers. On the federal level, however, no new legislation resulted from this report.

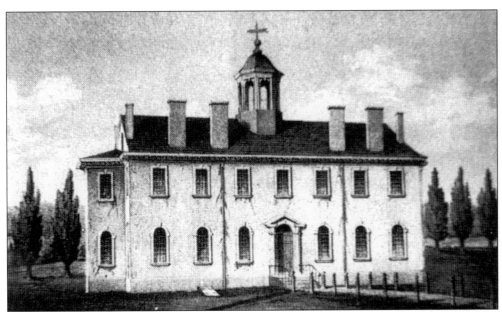

New Jersey canal supporters had not been idle during these years. The New Jersey Navigation Company was incorporated in 1804 but did not last due to lack of funds. In 1820, the legislature incorporated the New Jersey Delaware and Raritan Canal Company, but this endeavor failed as well. In 1823, a commission reviewed the route that was surveyed in 1816, but by then there was talk of a competing northern canal, the Morris. In 1824, however, the commission presented to the legislature a proposal calling for a 30-mile canal, 40 feet wide and 4 feet deep. A 22-mile feeder would channel water from the Delaware River to fill the canal. A new company was incorporated, and since Delaware River water was to be used, New Jersey entered into negotiations with the state of Pennsylvania. An agreement was finally reached, but the project was abandoned due to insufficient funding. The 1792 New Jersey State House is pictured here.

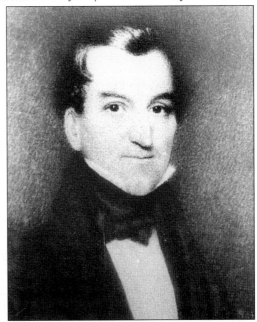

After several more years of failed attempts, a fourth and final act of incorporation of the Delaware and Raritan Canal Company became law on February 4, 1830. The act appointed five commissioners—James Parker, James Neilson (pictured), John Potter, William Halstead, and Garret D. Wall. Among the provisions were these: the canal company would be organized when 5,000 shares of stock had been sold; if they were not subscribed within a year, the charter would be void. On the same day, the legislation granted incorporation to the Camden & Amboy Railroad.

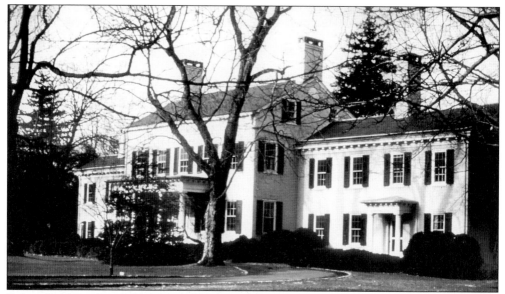

Robert Field Stockton of Princeton, New Jersey, was the grandson of Richard Stockton, a signer of the Declaration of Independence. In 1811, he joined the U.S. Navy and saw duty in both the War of 1812 and the Barbary Wars. On a cruise to the southern states, Stockton met and married Maria Potter, the daughter of a wealthy Charleston planter. Returning to Morven (pictured), his home in Princeton, in 1828, Stockton took an intense interest in the completion of the proposed canal.

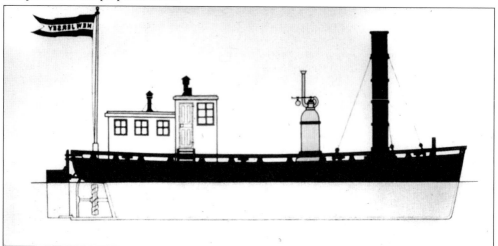

Seeking financial backing for the canal project, Stockton met with capitalists in Philadelphia and New York, but they thought the enterprise too risky to support. After the first three days of stock sales in late March, only 1,134 shares had been sold. The Camden & Amboy Railroad, on the other hand, was fully subscribed in 10 minutes. Stockton then persuaded his father-in-law, John Potter, to provide the funds to buy 4,800 shares, thus validating the charter. While in England to secure loans from the London banks, Stockton met John Ericsson, inventor of the screw propeller, and contracted Lairds and Company to build an iron-hulled steamship with a screw propeller for use on the Delaware and Raritan Canal. In 1839, the *Robert F. Stockton* crossed the Atlantic under sail, the first iron-hulled vessel to do so. Renamed the *New Jersey*, it towed boats on the canal and the Delaware River for more than 30 years.

Nine directors were chosen for the Delaware and Raritan Canal Company, and they, in turn, elected Robert F. Stockton as president, James Neilson as treasurer, and John Thomson as secretary. Canvass White was appointed chief engineer. White, Benjamin Wright, and Ephraim Beach Jr. (pictured) had surveyed the route for the new canal; all three had experience building the Erie Canal in New York. White proceeded up the Delaware River in June 1830 to survey the route of the feeder canal.

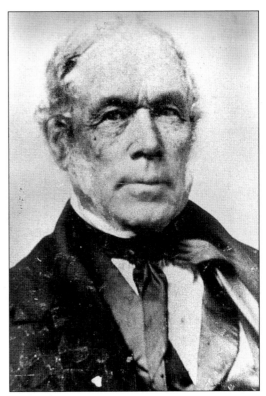

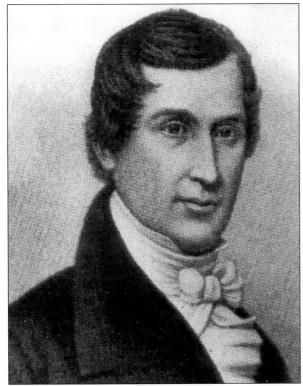

Canvass White (pictured) began his engineering career on the Erie Canal in 1816 under Judge Benjamin Wright. The following year, he visited England to study the canals. Returning home, White discovered and patented hydraulic cement. He continued work on the New York state canals until 1824. From 1824 to 1826, he served as chief engineer on the Union Canal. He was appointed chief engineer of the Lehigh Canal in 1827 and of the Delaware and Raritan Canal in 1830. White was also the consulting engineer for the Schuylkill Navigation Company and for the Chesapeake and Delaware Canal.

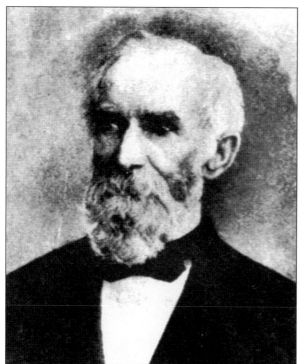

Canvass White divided the construction of the main canal into three sections, with a different supervisor for each. Ashbel Welch (pictured), who had begun his career on the Delaware and Lehigh Canals, oversaw the building of the feeder. When an epidemic of Asiatic cholera broke out among the workers, Welch appointed a board of health that had power to require compliance with sanitary measures among the townspeople as well as the workers. In the fall of 1834, soon after the canal was finished, Canvass White died. Welch was appointed as the successor to his esteemed chief engineer.

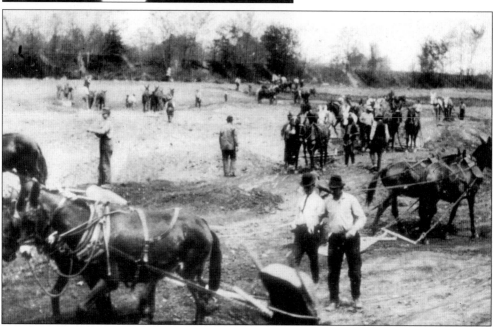

The Delaware and Raritan Canal was dug mainly by hand, without the advantage of today's heavy machinery. Immigrant and local laborers used picks and shovels, and animals pulled scrapers that moved the earth to create the 44 miles of the main canal and 22 miles of the feeder. Although there were no photographs taken during the construction (1830–1834), this photograph of the construction of Lake Carnegie (see page 32) shows the typical workmen and methods that would have been used.

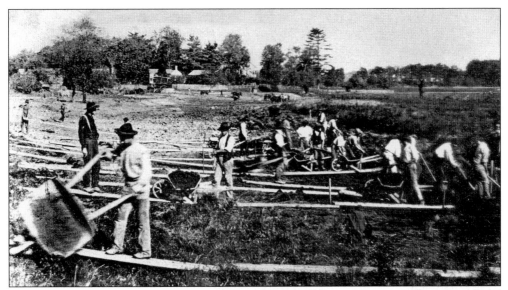

The first shovelful of earth for the canal was turned near Kingston. Contracts were let to local contractors for specific sections of the waterway. The contractors, in turn, hired millwrights, masons, foremen, carpenters, and day laborers. On other canal projects, it has been said that the workers were paid partly in liquor. On the Delaware and Raritan, however, the contracts prohibited the contractor from giving or selling liquor to his workmen or even allowing it to be brought near the canal. Whether this provision was enforced is hard to determine.

In order to prevent the water from seeping into the ground, the bottom of the canal was covered with a layer of clay, cut into slabs. The workers "puddled" the clay to ensure that the slabs were joined, tightly sealed, and watertight. This process involved mixing sand, water, and clay into a smooth paste and kneading it by walking on it and working it with tools to press the seams together. In this photograph, the canal has been partially drained, revealing the clay liner.

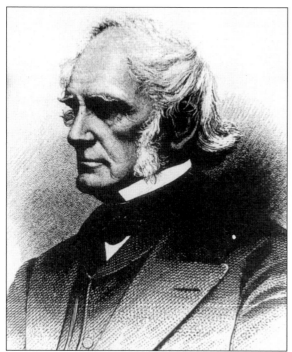

The Delaware and Raritan Canal officially opened on June 25, 1834. In a two-day tour, Gov. Peter Vroom (pictured), company directors, major stockholders, and other dignitaries traveled on the feeder and then on the main canal from Trenton to New Brunswick in a boat borrowed from the Chesapeake and Delaware Canal. The party was greeted at New Brunswick with a 24-gun salute and treated to a sumptuous dinner.

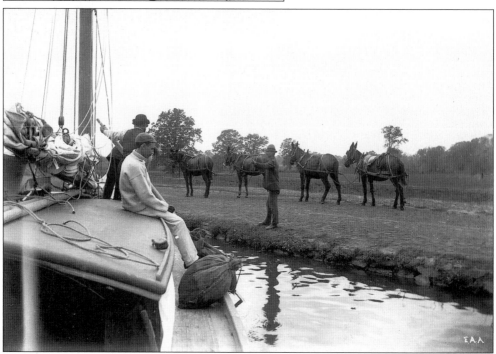

Throughout most of the canal's 98 years of operation, mules were used to tow canalboats. Early on, steam-powered vessels began to use the waterway, but mules and sometimes horses continued to be used as well. In pairs or teams of four, these sturdy animals pulled loads of up to several hundred tons, plodding along the dirt towpath for 44 miles. In the final years after World War I, only steam, gasoline, and diesel propulsion were used.

Mileposts were installed at every mile along the towpath. Placed deep into the ground and at an angle to the towpath, each marker displayed two numbers. Going downstream, the number facing the mule driver told him how far it was to New Brunswick. Turning around, the mule driver could read the number that gave the mileage to Bordentown. Together, these numbers always totaled 44, the length of the main canal.

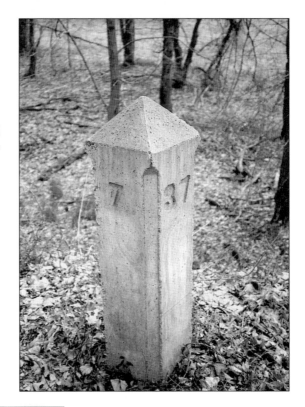

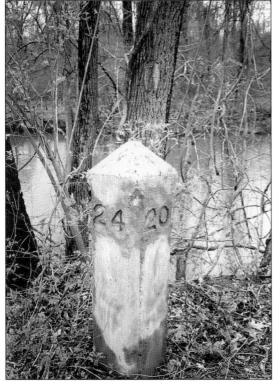

The marker in the previous photograph shows 7 and 37, and this one reads 24 and 20. A slightly fancier post reading 22 and 22 marks the halfway point, near Rocky Hill. After the Pennsylvania Railroad leased the canal, the original wooden mileposts were replaced with cast-concrete posts. Along the feeder, the railroad installed cast-iron posts.

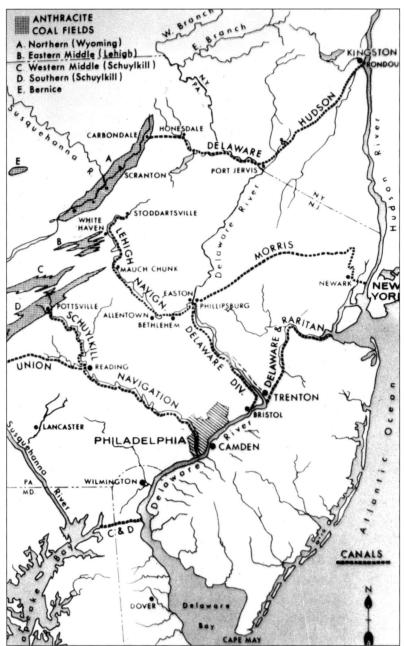

ANTHRACITE
COAL FIELDS
A. Northern (Wyoming)
B. Eastern Middle (Lehigh)
C. Western Middle (Schuylkill)
D. Southern (Schuylkill)
E. Bernice

Once New York's Erie Canal was completed in 1825, canal fever broke out throughout the
eastern states. Canals were constructed from Maine to Georgia and from the Atlantic coast to
Illinois. Some bypassed rapids or waterfalls, while others connected inland regions to port cities.
Still other waterways joined two bodies of water. This map shows many of the anthracite canals,
so called because they carried hard coal from northeastern Pennsylvania to the cities and
industries of the tri-state region. Today, most of these waterways have been abandoned. Solitary
sections of canal or overgrown locks can be found in the woods and meadows. The Delaware
and Raritan Canal and Pennsylvania's Delaware Canal are among the very few that remain,
nearly intact and watered.

Two

ON THE DELAWARE:

BORDENTOWN AND TRENTON

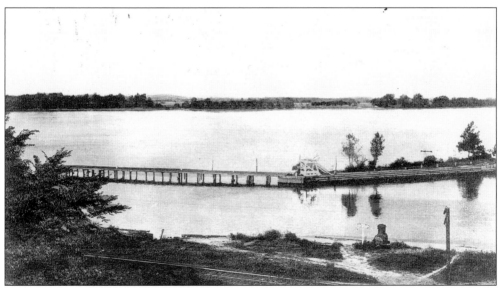

The Delaware and Raritan Canal began here, where Crosswicks Creek enters the Delaware River. Looking north from the bluff in Bordentown, this photograph shows the entrance to the canal, with the mouth of the creek in the foreground. Lock No. 1, just out of view to the right, was a tide lock; its lift depended upon the tidal level of the river. The pier at the left, jutting out toward the Delaware River, guided the boats in toward the lock and provided a place to moor while waiting to enter the lock. The rail line in the foreground connects Bordentown with Trenton. It was built by the Camden & Amboy Railroad and will one day host passenger trains of the Southern New Jersey Light Rail Transit system.

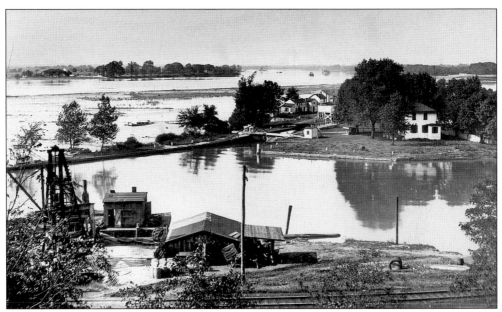

This view, taken from a point on the bluff just east of the previous photograph, shows the lock at the center. Due to its location at the southern terminus, Lock No. 1 was the site of the toll collector's office and home, the locktender's house, and a mule barn. This is the second version of Lock No. 1. The original masonry lock, farther to the east, failed, breaking apart in the marshy soil along the creek. In 1847, the canal company replaced it with a wooden lock that was floated to the current site and weighted down with rock and fill.

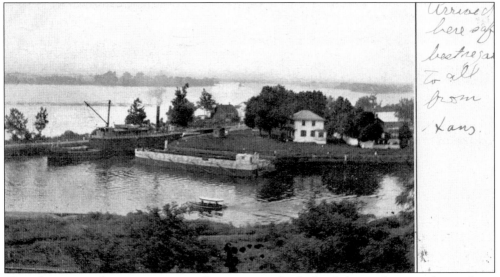

This closer view shows a steam canalboat exiting the lock while another vessel is tied up, possibly awaiting a tow down the Delaware River to Philadelphia. Interstate 295 has been constructed on the marshy area between the lock and the Delaware River. The Lock No. 1 area is usually referred to as the Bordentown section of the canal. Actually, the city of Bordentown is located on the south side of Crosswicks Creek; technically, the canal began on the north side of the creek, in Hamilton Township. Today, only the lock and the building foundations remain in this area, which is slated for development by the state park system for recreational use.

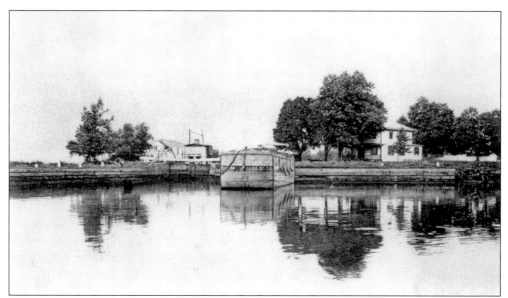

This view from Crosswicks Creek is the way the boatmen would have seen the approach to Lock No. 1. The timber cribbing along both sides provided space to tie up while waiting to lock through. This vessel, heading into Crosswicks Creek, may be waiting for a steam tug to tow it to Philadelphia or farther south to the Chesapeake Bay. Prior to 1916, "Skukers" entered the canal at this terminus. These boats, loaded with several hundred tons of coal, had descended Pennsylvania's Schuylkill Navigation.

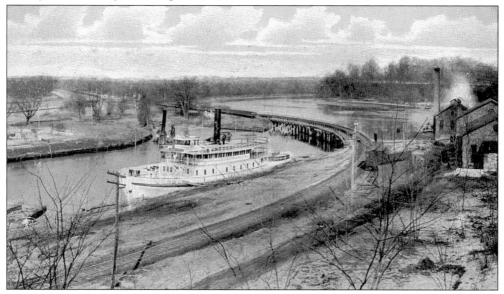

Just to the east along Crosswicks Creek is the curved trestle of the Pennsylvania Railroad, originally the Camden & Amboy, heading north to Trenton. The rail line and the trestle were completely rebuilt for the Southern New Jersey Light Rail Transit System that will carry passengers between Camden and Trenton. A pedestrian bridge along the trestle will allow canal park visitors to reach the lock site. The original entrance lock to the canal was located approximately above where the pilothouse of the steamboat *Springfield* appears in this photograph. The boat is tied up, awaiting its next load of passengers bound for Philadelphia.

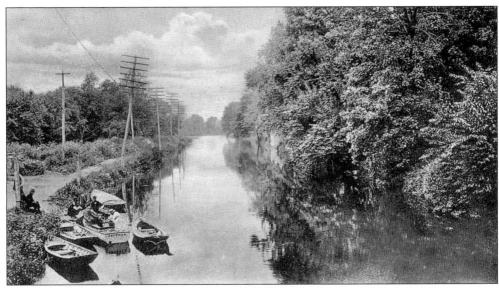

As the canalboats headed north toward Trenton, they passed through this undeveloped region, today known as the Hamilton-Trenton Marsh. The marsh, a unique urban wetland, features the Abbott Farm National Historic Landmark, home to Native Americans for 10,000 years. Both the canal and the railroad passed through the marsh, once the site of the White City Amusement Park. The remains of sunken canalboats are known to exist in Crosswicks Creek.

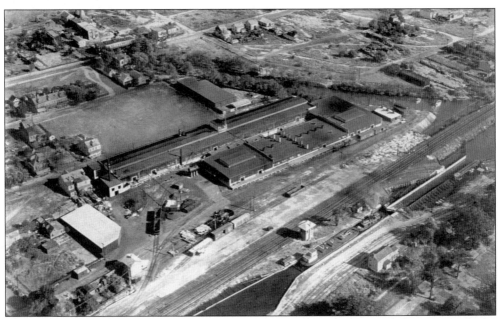

At Lock No. 4, south of Lalor Street in Trenton, a steam tug and its tow can be seen inside the lock, heading south. The miter gates, in front of the tug, are always pointed upstream so that the water pressure will keep them closed as the lock fills or empties. The track on the east side of the lock is the Bordentown branch of the Pennsylvania Railroad. When the canal was enlarged in 1853, Lock No. 5 was eliminated. To compensate for this, the lift at Lock No. 4 was increased to 12.4 feet, giving it the highest lift along the waterway.

Born in Muhlhausen, Germany, John August Roebling (1806–1869) immigrated to the United States in 1831, hoping to establish a utopian colony for German-speaking intellectuals in western Pennsylvania. The effort failed, and to survive, Roebling became a canal surveyor. In the 1840s, he began making wire rope, by hand, on his farm. By 1845, Roebling had constructed the Allegheny Aqueduct for the Pennsylvania Main Line Canal. In 1848, Roebling moved to Trenton. While his factory was under construction, he was already working on aqueducts for the Delaware and Hudson Canal. His work can be seen today on the restored aqueduct that crosses the Delaware River between Lackawaxen, Pennsylvania, and Minisink Ford, New York, north of Port Jervis, New York.

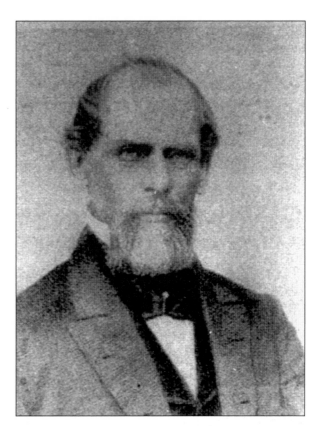

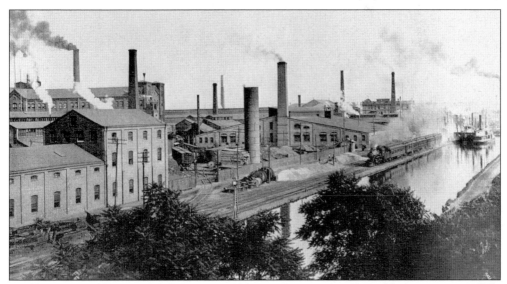

Roebling opened his manufacturing operation in Trenton in 1849. The site was carefully chosen to take advantage of the Delaware and Raritan Canal and the Camden & Amboy Railroad, both of which adjoined the property. Roebling's mills manufactured the wire rope cable used to raise and lower the canalboats on the inclined planes of New Jersey's Morris Canal. The cable proved safer and more durable than the iron chains previously in use.

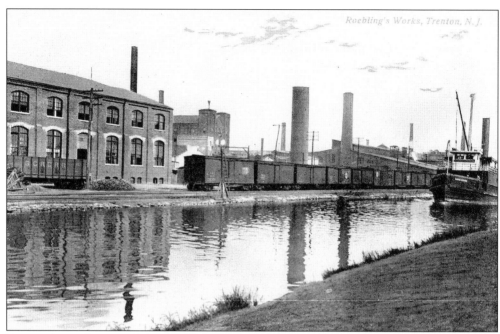

During the early years, John A. Roebling's wire rope factory in Trenton used water power supplied by the Delaware and Raritan Canal. On the left, one can see the intake for the water. After his death, Roebling's four sons were left in charge. Charles (1849–1918) ran the production end, and Ferdinand (1842–1917) handled marketing. Washington (1837–1926) provided executive leadership after overcoming a severe nervous breakdown caused by the bends, or caisson's disease, which affected him during the building of the Brooklyn Bridge. Edmund (1854–1930) chose not to be involved at all in the business.

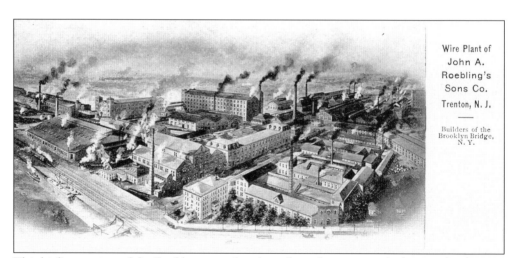

This bird's-eye view of the Roebling complex shows how the company had grown by the turn of the century. In 1918, its peak production year, this industrial complex employed more than 8,000 people with annual sales of $47 million. After the founder's death in 1869, the company name was changed to John A. Roebling's Sons. This tactic allowed the sons to change the name while following the stipulation of their father's will that his own name remain.

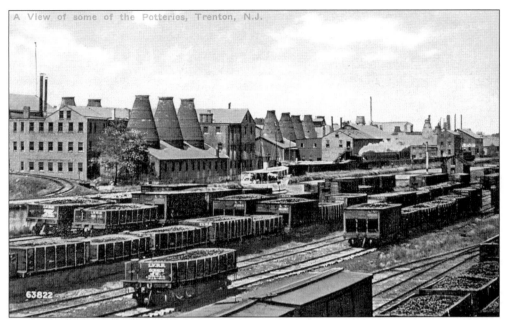

For more than 100 years, Trenton was a major pottery center. Beginning with two firms in 1853, the industry grew to more than 50 potteries at its zenith in the 1920s. Today, important companies remain, including Cybis, Boehm, and American Standard. The Enterprise Pottery, with its distinctive cone-shaped kilns, is shown in this photograph. A yacht (center) is proceeding north on the canal; the steam locomotive (right, center) is on the Enterprise branch of the Pennsylvania Railroad.

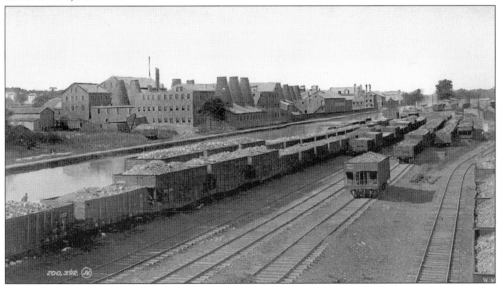

Enterprise Pottery (1879–1841) was the first pottery built in the United States for the sole purpose of manufacturing sanitary porcelain (bathtubs, sinks, toilets, and so on). This scene also shows Lehigh Valley Railroad cars loaded with coal, possibly awaiting transfer to canalboats. This was a Pennsylvania Railroad yard known as Coalport, and the Lehigh Valley cars were brought here from Phillipsburg by the Pennsylvania Railroad via their Belvidere-Delaware branch that ran along the canal feeder.

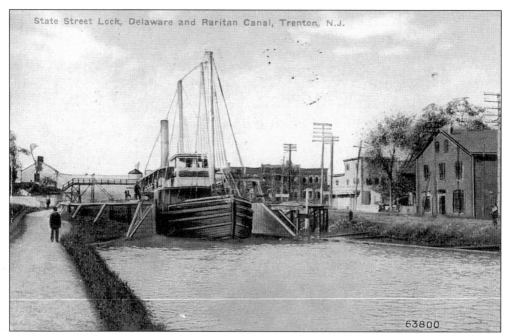

63800

The steam canalboat *F.W. Brune,* exiting the State Street lock (Lock No. 7), has just left the summit level of the canal, heading south to Bordentown. The Pennsylvania Railroad can be seen on the right. The railroad paralleled the canal in Trenton. The bridge behind the canalboat was used to allow pedestrians to cross the canal when the busy State Street bridge was open.

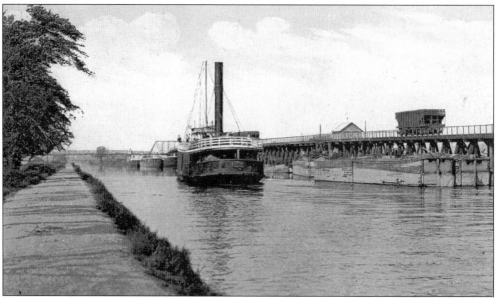

In the Coalport section of the city, great quantities of coal were shipped by rail and canalboat. Anthracite arrived by train from the coal fields of northeastern Pennsylvania. In Trenton, the coal cars were pushed up onto a railroad trestle next to the canal. Canalboats maneuvered alongside the trestle under the coal chutes, and coal roared down from the rail cars, filling the holds of the boats. The coal was then transported to tidewater consumers primarily in the New Jersey–New York harbor area but also to the towns and businesses along the canal.

Three
PEOPLE AND TOWNS

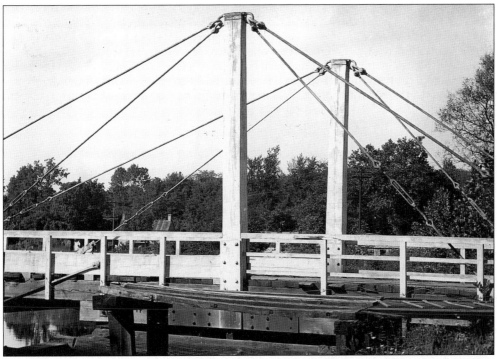

This close view shows the king-post bridge at Port Mercer in 1935. Originally, the swing bridges were built in the A-frame style. Over the years, however, as cars and trucks replaced horse-drawn wagons, heavier vehicles crossed the canal bridges. The king-post design, providing more strength, eventually replaced the A-frames. To operate the span, the bridgetender pushed a 10-foot pole and "walked" the bridge, which was balanced on three sets of eight-inch iron wheels. As the wheels rolled around a circular rail, the bridge swung to one side of the canal on a turntable. After the canal closed, the bridges became immovable and were gradually replaced with fixed spans.

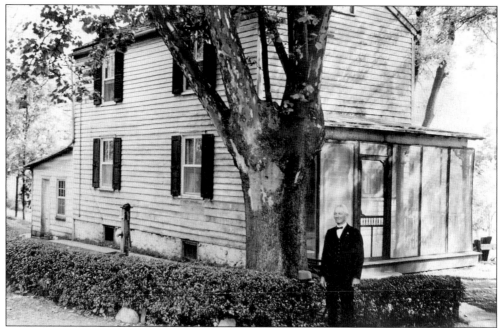

The Delaware and Raritan Canal Company provided homes for the locktenders and bridgetenders. Here at Port Mercer, bridgetender John Arrowsmith poses proudly in front of his home, now the headquarters of the Lawrence Historical Society. Arrowsmith tended the bridge from 1900 until the canal closed in 1932. When his children heard the sound of the conch horn, steam whistle, or air horn, they knew it was time to help swing the bridge. By canal regulation, the boat captains would have to alert the lock or bridgetender of their imminent arrival.

In 1931, with the completion of U.S. Route 1, this unique lift bridge was installed across the Delaware and Raritan Canal at Baker's Basin in Lawrence Township. The highway intersected the canal at a 24-degree angle, requiring 110-foot girders to support the bridge. An electric motor and gear drive powered the gear track, the curved mechanism seen at the top of the structure, which opened the span. This complex lift bridge operated for only two years before the canal was closed.

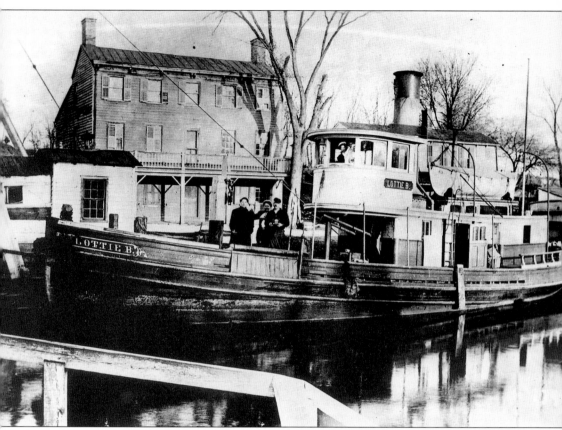

A popular stopping place was the Railroad Hotel along Alexander Road, formerly Canal Road. Built *c.* 1834, it served merchants and workmen who came to Princeton Basin. A branch of the Camden & Amboy Railroad was completed on the east side of the canal, in front of the hotel, in 1839. This formed the first continuous rail route from Philadelphia to the Hudson River, opposite New York City. In 1864, when the railroad relocated the tracks to Princeton Junction, the hotel was renamed the Steamboat Hotel and continued to serve canal travelers. When the canal closed, the building was converted to apartments. The hotel stood until 1992, when it was demolished due to its deteriorating condition. The steam tug *Lottie B.*, towing a canalboat downstream toward New Brunswick, is about to pass through the Alexander Road swing bridge (lower left corner). Princeton Basin was a freight depot on the canal. Businesses situated around the basin included a sash and blind factory, Scott Berrien's General Store, Fielder's Lumber and Coal, and Billy Lynch's Bottle House, advertising liquor "as cheap as any other."

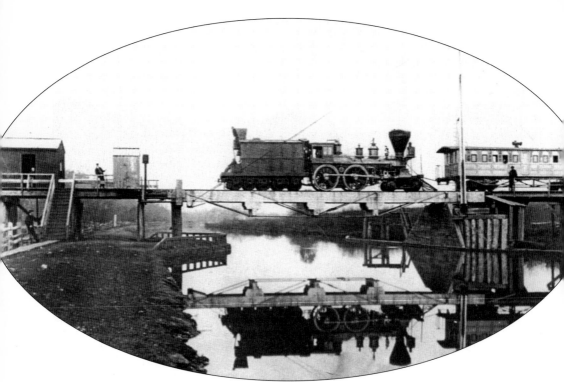

The main line of the Pennsylvania Railroad bypassed the borough of Princeton in 1865, locating its station instead at Princeton Junction. The nearly three-mile Princeton branch line was built to serve the town. Known as the "dinky," it operated with an engine and a passenger car. Also called the PJ & B, an acronym for Princeton Junction and Back, the dinky crossed the canal on a swing bridge. This popular train has carried commuters as well as college students en route to New York and Philadelphia via the main line. Over the years, five different companies have operated the line: the Camden & Amboy Railroad, the Pennsylvania Railroad, the Penn Central, Conrail, and now New Jersey Transit. Here, the dinky engine and passenger car are reflected in the waters of the canal. The curved extension of the towpath, on the left near the pier, allowed the mules to pass around the bridge support without unhitching the towlines.

This view looking north from the dinky swing bridge shows the towpath very clearly. While the berm (opposite side from the towpath) has lush vegetation, the towpath is clear. The canal company hired "level walkers" to constantly check the banks for signs of muskrats. Finding their burrows, these employees would call for a "ratter," such as Obie Ayres, the unofficial trapper of the canal. Ayres trapped mink, skunk, groundhogs, and most importantly, muskrats; these animals often burrowed into the canal bank, weakening it and causing washouts.

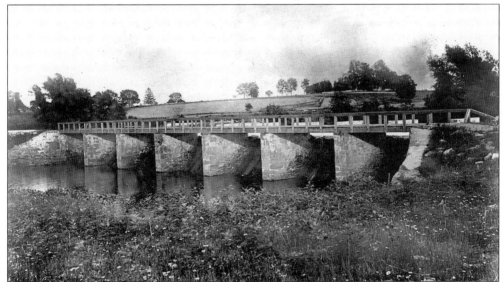

The simplicity of a canal is that it always tries to follow the most level terrain. Sometimes, however, a stream, a valley, a railroad, or a road bisects this right-of-way. To cross "on the level," the canal builders construct an aqueduct, or water-filled bridge. In Plainsboro, the canal crossed the Millstone River in a semi-watertight wooden trunk, supported on six stone columns. A walkway for the mules was constructed on the towpath side. This view shows the aqueduct prior to the construction of Lake Carnegie.

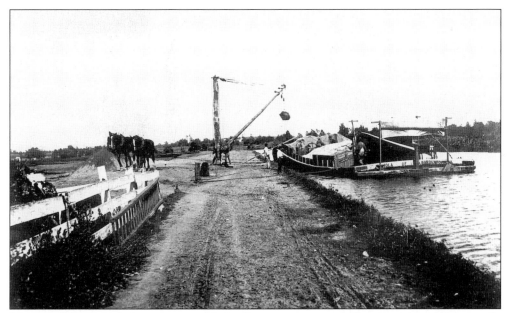

The canal facilitated the creation of Lake Carnegie because bulk materials could be easily transported to the construction site. Here, workers on the canalboat *Iola* are shoveling sand into a bucket that will be attached to the boom. As an empty bucket is swung over to the boat for another load, the horses provide the power for the hoist. Canalboats delivered the sand, aggregates, and cement for the dam that created the lake.

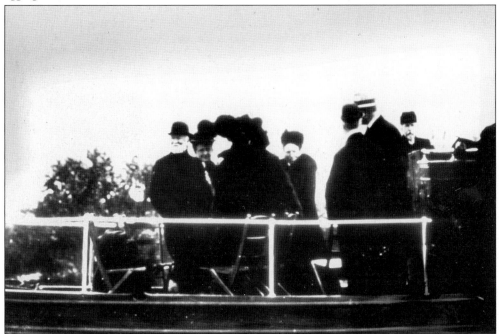

On December 6, 1906, the lake was dedicated in a formal ceremony aboard the vessel *Relief*, with Andrew Carnegie and his wife as the guests of honor. Many dignitaries from Princeton University and from the town were in attendance. The Rowing Association was soon reinstated and held its first regatta on the new lake in 1907.

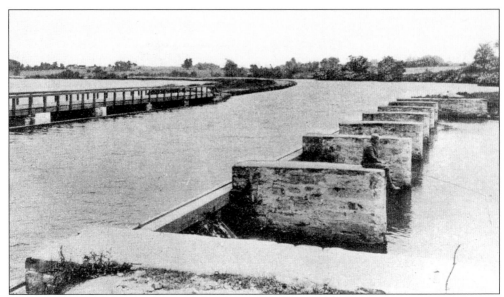

After the lake was completed, the level of the Millstone River rose to a point just below the aqueduct. This photograph clearly shows that the aqueduct is nearly submerged by the waters of Lake Carnegie. Only the tops of the stone piers are visible. Today, the trunk of the aqueduct is made of reinforced concrete. The man sitting on the pier is fishing in the Millstone River.

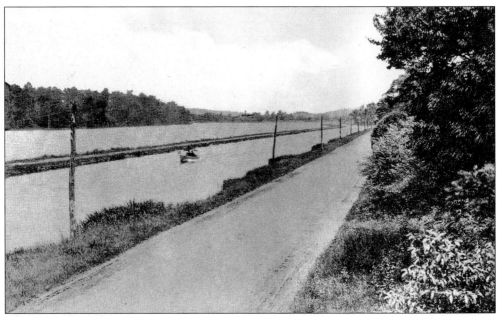

The Delaware and Raritan Canal parallels Lake Carnegie for more than two miles, from the Millstone Aqueduct to Lock No. 8 in Kingston. This section of the towpath is now very popular with joggers, walkers, and bicyclists. Benches afford a peaceful place from which to watch the birds, the ducks, and the Princeton rowing crews. In this photograph, you can see the towpath on a narrow strip of land, separating the lake from the canal. Mapleton Road follows the canal on the right.

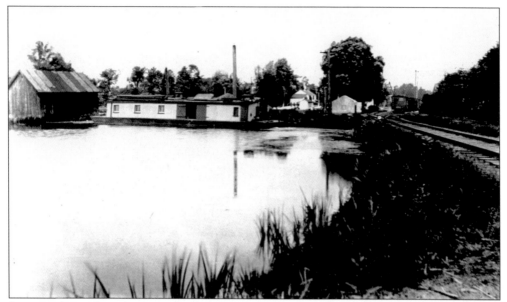

In many places along the waterway, basins such as this one at Kingston were constructed. These wide waters allowed vessels to pull off to the side, out of the way, and not disrupt traffic in the main channel. Businesses were often located around the basins so that vessels could easily be loaded or unloaded. Boatmen could also tie up for the night. The Rocky Hill branch of the Pennsylvania Railroad paralleled the canal from this point to the Atlantic Terra Cotta Company, beyond the Rocky Hill station.

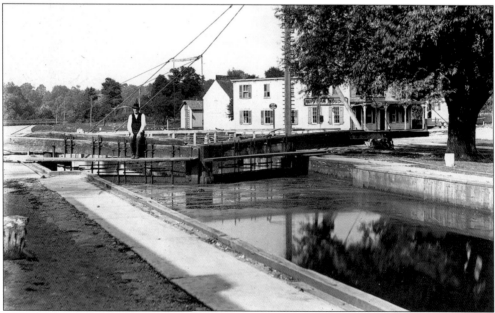

The lock at Kingston is full, waiting for the next northbound boat to lock down. The locktender, enjoying a well-deserved rest on the miter gate, will soon use a lever to turn the vertical rods seen above the gates in front of the balance beam. These rods will open the wickets, small doors below the water level, to allow the water to flow out of the lock. This procedure allows a northbound boat to descend or a southbound boat to enter and be raised to this level.

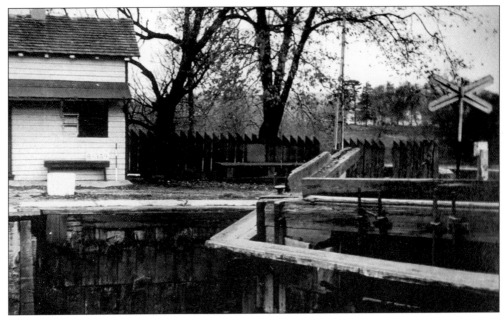

This closer view of the miter gates shows the narrow planks along which the locktender walked to open and close the wickets. It also shows the vertical rods that the locktender turned to operate the wickets. The wooden sheathing on the wall of the lock protected the vessels from scraping the stone wall of the chamber. The small building is the only surviving canal telegraph office. Note the cast-iron railroad grade crossing sign.

On the upstream end of the canal's locks, drop gates were installed, beginning in 1849. The gate would be lowered to rest on the bottom of the canal to allow vessels to pass over it. Taken by author James Cawley, this photograph shows the cast-iron wheels that opened the drop-gate wickets and raised the submerged gate. One of these wheels is displayed at the museum of the Canal Society of New Jersey, in Waterloo Village, Stanhope, New Jersey.

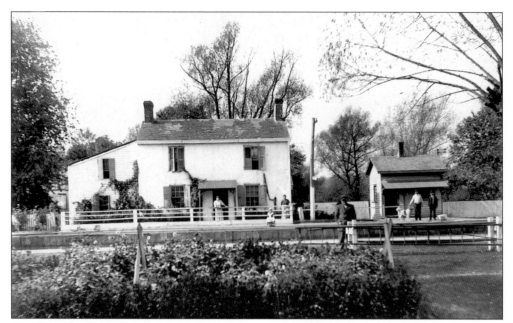

The Kingston locktender's house is the large white building on the left. Today, it houses exhibits, including the architectural plans for the lock, part of the 1937 Historic American Buildings Survey documentation. The smaller building housed the telegraph office from which canal company employees reported breaks in the canal bank, changes in water level, and boatmen who violated the speed limit of four miles per hour.

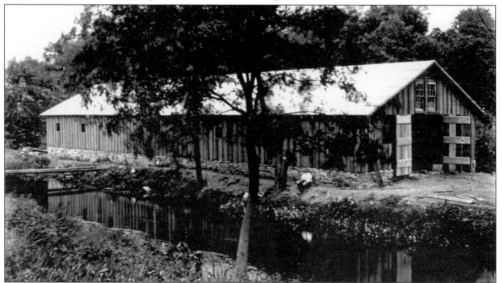

At first, teams of mules pulled canalboats and sailing vessels. They were gradually supplanted by steam canalboats, steam tugboats, and other self-propelled vessels. Known as shave tails, the wild mules were broken in by mule skinners hired by the canal company. Unlike horses, which might jump into the canal for a drink and drown, mules were generally afraid of water. Containers of oats were kept aboard the boats. Most captains treated their animals well, for without these living, breathing engines, they would not get very far. This mule barn at Kingston was on the berm side of the canal.

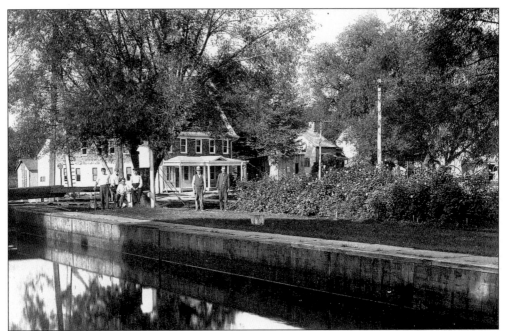

Looking across Lock No. 8 to the northwest provides a view of the Hoffman House, a hotel along the King's Highway. Later known as the Tannhauser Hotel, it burned in 1910, was rebuilt as the Kingston Hotel and Rathskeller, and burned again in 1943. The King's Highway Historic District was placed on the State and National Registers of Historic Places. The road passes through the Kingston Mill Historic District, which includes the adjacent 1798 quadruple stone arch bridge.

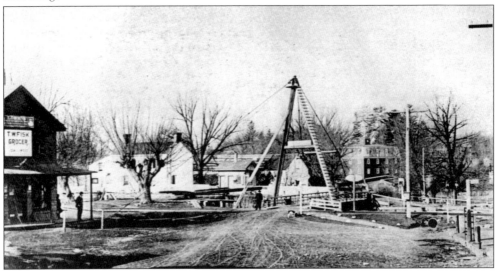

This overall view, looking southwest, shows the center of activity in the area of the Kingston lock. From the left we see the grocery store of T.W. Fisk, the locktender's house, the telegraph office, and the A-frame swing bridge. The dark building in the distance, to the right of the bridge, is the Kingston Flour Mill, a vertical-shaft turbine mill. The four-story structure used the water power of the Millstone River to produce flour for about 150 years, ending in 1943. Since then it has served mainly as a residence.

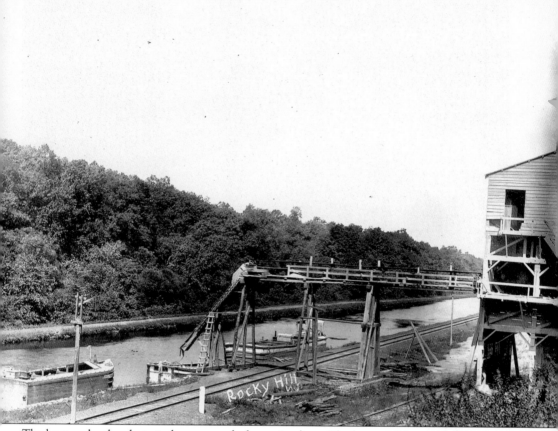

The boat under the chute is the stern end of a section boat. The bow, visible on the left, is part of the same vessel. The boat is sitting high in the water, meaning that it is empty, or light, awaiting a load of stone from this quarry north of Kingston. Section boats were often used on narrow canals. They could be separated, turned around in the channel, and rejoined to resume their journey. On the Morris Canal, the waterway that served northern New Jersey, only section boats were used. On the Morris's 23 inclined planes, the boats were separated to travel up or down the inclined planes in cradles.

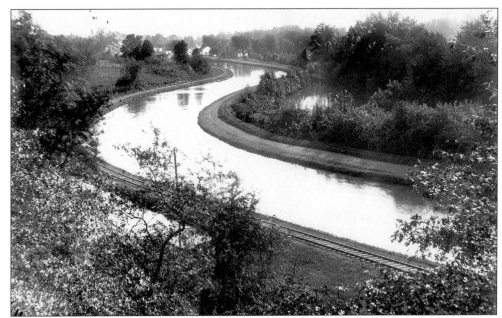

Canal engineers surveyed to determine the flattest course for their waterways. This was not, however, always the straightest path, as this section north of Kingston demonstrates. Both the canal and the Rocky Hill branch of the Pennsylvania Railroad followed the contour of the land and the flood plain of the Millstone River. The steam locomotive *John Bull* operated on this railroad branch, on the Princeton branch, and along the canal from Bordentown to Kingston in its final years of service. It was the first locomotive of the Camden & Amboy Railroad and the first to travel across the state of New Jersey. The *John Bull* is on permanent exhibition at the National Museum of American History of the Smithsonian Institution in Washington, D.C.

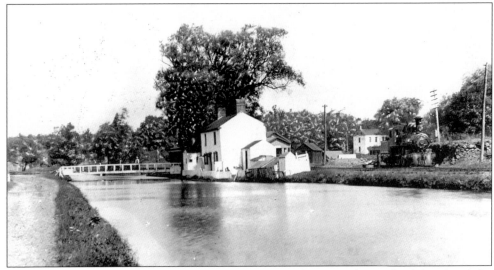

In this view, looking north into Rocky Hill, we see the towpath on the left side of the photograph. The mules that plodded along here were probably accustomed to the noisy, smoking locomotives that passed them on the opposite, or berm, bank. Today, a public parking area is located near the locomotive and tender. The bridgetender's house is gone; in its place is a stone outline of the original foundation.

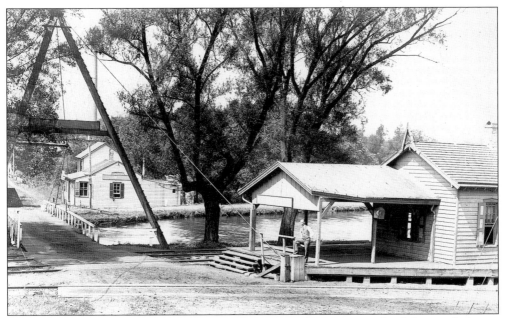

The station at Rocky Hill served the town that was on the opposite side of the canal. Across the bridge is the famous McCloskey's Tavern, a favorite haunt of many a boatman. Barney McCloskey, the proprietor, was a well-known figure in Rocky Hill and the star of the local baseball team. Today, the tracks, the station, and the bar are gone, but the current bridge still has a wood-planked deck, and some rails still remain along the canal bank to the rear of the station site. A parking lot for canal park users now occupies the site of McCloskey's.

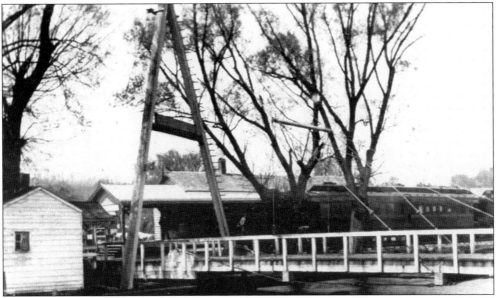

The Rocky Hill station served as a passenger and freight depot for the Rocky Hill Railroad and Transportation Company. This nearly three-mile spur of the Camden & Amboy Railroad ran from Kingston, past the quarry, to the Atlantic Terra Cotta Company, north of Rocky Hill. Built in 1864, the line discontinued operations to the terra cotta in 1928 but continued to serve the quarry until midcentury.

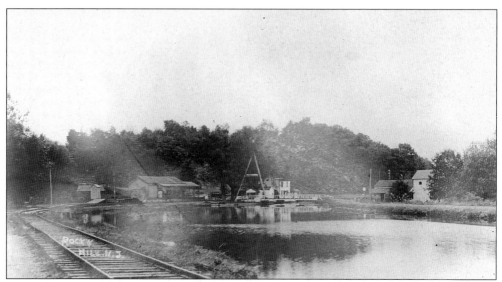

This bucolic view, looking south toward Rocky Hill, gives an overall picture of the activities at the busy crossroads. To the left of the A-frame bridge is the Rocky Hill Railroad Station. Just beyond is the bridgetender's house and across the canal on the right is McCloskey's Tavern. The bridgetender's house burned in 1925 and was replaced by the mule drivers' bunkhouse from Bordentown. The new building was placed on a boat at Lock No. 1 and floated to its new home in Rocky Hill. The tracks in the foreground lead to the Atlantic Terra Cotta Company, behind the photographer.

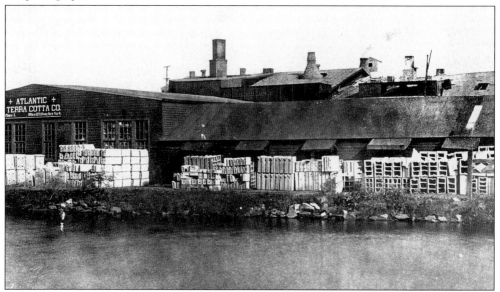

The Atlantic Terra Cotta Company, consolidated from three separate firms in 1907, became the world's largest manufacturer of architectural terra cotta. For more than three decades, it provided veneers and decoration for many American buildings, including the Woolworth Building in New York City and the Philadelphia Museum of Art. Begun as a brick manufacturer in 1892, the company was drawn to Rocky Hill by the nearby clay pits, the water transportation of the Delaware and Raritan Canal, and the Pennsylvania Railroad, which siphoned off most of the freight traffic.

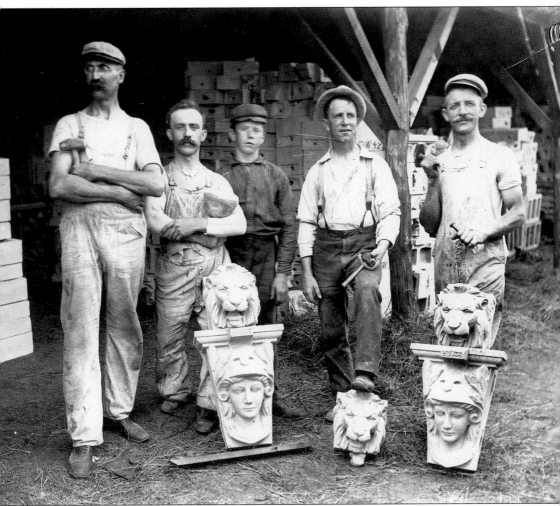

In its heyday, the Rocky Hill works of the Atlantic Terra Cotta Company employed between 200 and 300 workers and operated nine kilns. Many of the craftsmen were Italian immigrants who settled permanently in Rocky Hill. These artisans were skilled in the manufacture of glazed architectural terra cotta, a popular masonry building material. It was comparatively lightweight, durable, and available in a variety of colors and textures. Terra cotta architectural ornamentation was used for apartment buildings, office buildings, hospitals, hotels, railroad stations, stores, theaters, banks, post offices, churches, and schools throughout the country. In 1919, the company purchased additional land and built a large guesthouse for visitors, known locally as the Terra Cotta Hotel. The company closed in 1943. Today, only the brick powerhouse, an office building long since converted into a residence, and two vine-covered kilns mark the site of this once significant commercial venture.

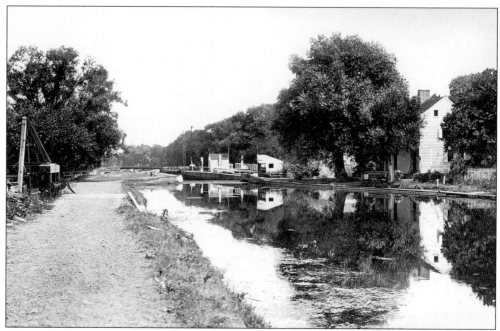

The canal was designed to hold a specific amount of water. After a heavy rain, too much water could overflow the banks, leading to erosion and the possible rupture of the canal. To control the water level, the engineers constructed waste gates and weirs. Here, at Griggstown, a gate is located in the bank where the light-colored planking bisects the towpath. The gate releases water from the canal. The water flows under the towpath into a tributary of the Millstone River.

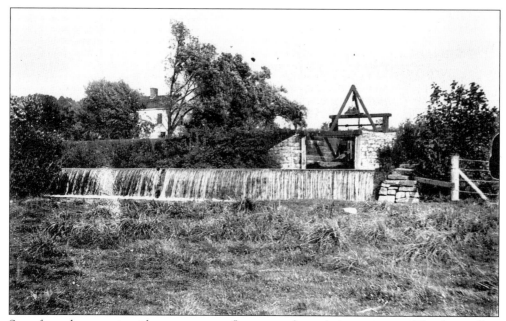

Seen from the opposite side, excess water flows over the weir into a stream. This heavy flow indicates a recent heavy rain. Without this escape valve, the water would overflow the banks and erode the towpath.

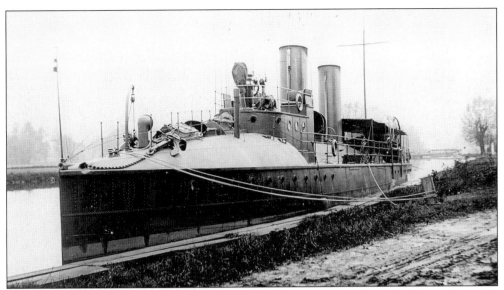

Since the Delaware and Raritan was part of the Intracoastal Waterway, luxury yachts often were seen on their semiannual trek between northern ports and winter vacation homes in Florida. Because the canal was usually closed at night, boats often tied up for the evening at one of the quaint villages along the canal, perhaps in South Bound Brook or Griggstown. Sometimes, the owners invited local residents to come aboard for a guided tour by liveried servants. George Rightmire, who lived opposite Lock No. 9 in Griggstown, photographed the Vanderbilt yacht, *Tarantula*, a converted military vessel.

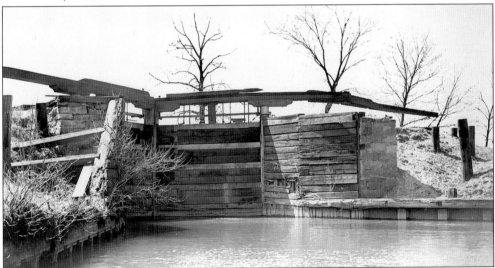

Here is an unusual close-up view of the downstream miter gates at Griggstown. The balance beams, seen across the top of each gate, protrude over the lock wall, enabling the locktender to push the gates open or closed more easily. The wooden fender visible in front at the waterline directs the vessel into the lock. A bypass channel was constructed, paralleling the lock. Water traveled through the bypass and reentered the canal downstream of the lock. Even when the locks were closed, the flow of water had to continue downstream, so the bypass channel was essential. The trees growing so close to the lock indicate that this photograph was taken after the canal was closed.

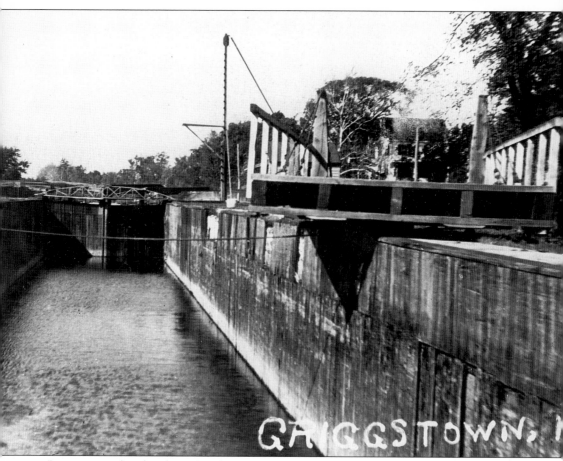

GRIGGSTOWN, 1

Peering into the chamber of Lock No. 9 in Griggstown, one is given an idea of its size. The miter gates are closed and pointing upstream, toward the photographer. On the right lock wall, the swing bridge is moving back out of the way so that a vessel, traveling upstream, may enter the chamber. The bridge is at the midpoint of the 220-foot lock, so the photograph shows only about 110 feet, which was the length of the original locks, before the enlargement. The Griggstown lock is an especially popular spot for local fishermen.

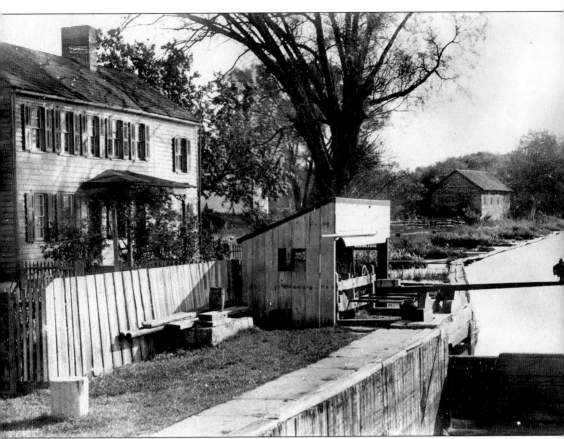

In this upstream view, taken from the bridge over Lock No. 9 at Griggstown, we see the shelter that protects the lock mechanism and the operator. This equipment was used to raise the drop gate and open the wickets. The locktender has placed a signal lantern on a pole to warn approaching boats that the gate is in the up position. The round object in the lower left is a snubbing post. Mule-pulled vessels had to use the snubbing post to stop before hitting the lock gates. A crew member looped a line around the post and pulled to stop the vessel. Surviving snubbing posts are constructed of concrete around a central cluster of old railroad rail driven into the earth. Powered boats could stop in a lock by reversing. On the left is the locktender's house, owned by the state park system and leased as a private residence.

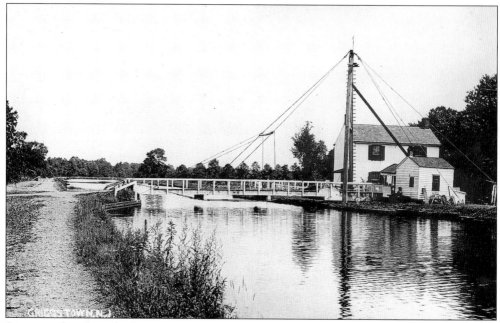

Seven tenths of a mile downstream from Lock No. 9, vessels passed through the swing bridge at Griggstown. To the right, in the foreground, the small building is a hut, or shack, in which the bridgetender would watch for approaching boats. He would then lower a gate across the Griggstown Causeway to block vehicular traffic and push or crank open the bridge. Most bridges had a winch to assist in opening. The bridgetender's home is the larger building.

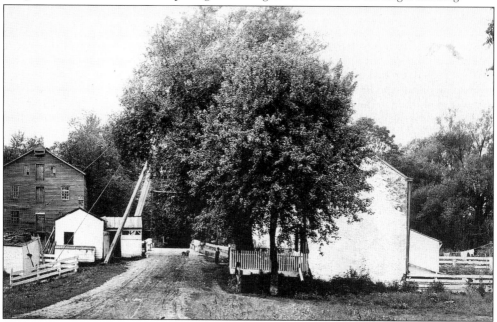

Looking west along the Griggstown Causeway, we see the bridgetender's home, with its white picket fence. The dark building on the left is the second mill in Griggstown. It was taken down in 1909; a private home now stands on the site. Here we get another look at the bridgetender's hut. After the canal closed, this building was used for a time as the Griggstown Library.

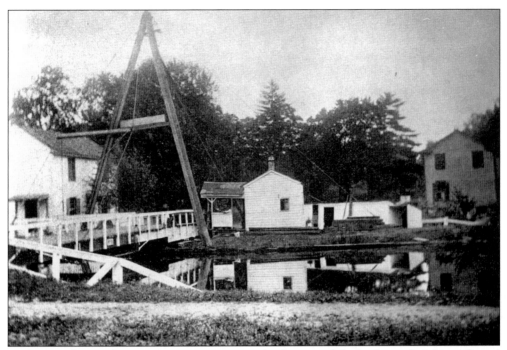

In this east-facing photograph, we see an unusual side view of the bridgetender's hut reflected in the calm waters of the canal. This rare view shows an addition to the hut—a roofed porch on which the gentleman is relaxing while awaiting the next vessel. The building to the left is his home.

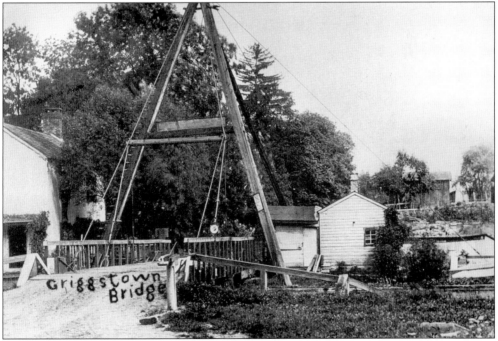

Looking east in this close-up, it is easy to see the cables and supports for the swing bridge. This closer view of the bridgetender's hut now shows that the porch area has been closed in.

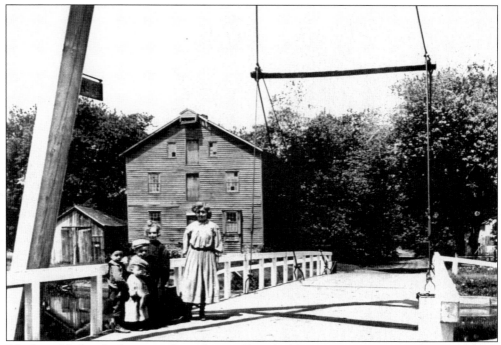

Abraham Veghte built two mills and a small outbuilding *c.* 1832–1834 at this location to replace the Griggs mill that was destroyed to make way for the canal. Veghte's slaves are said to have torn down the Griggs mill and may have incorporated the materials into the new mill. Abraham was responsible for clearing and digging sections 43 and 44 of the canal. The foundations of a mill are still there, although obscured by a modern foundation.

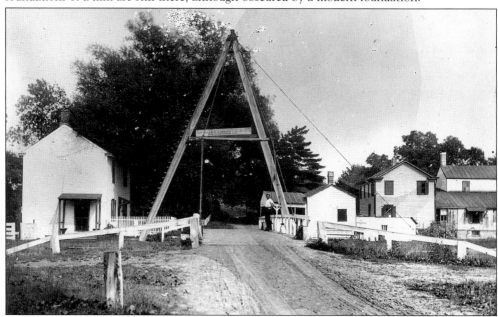

In this eastern-looking view, we see the bridgetender's home on the left. The buildings in the distance, at the intersection with Canal Road, housed several different establishments over the years, including a bottling company and a lumber business.

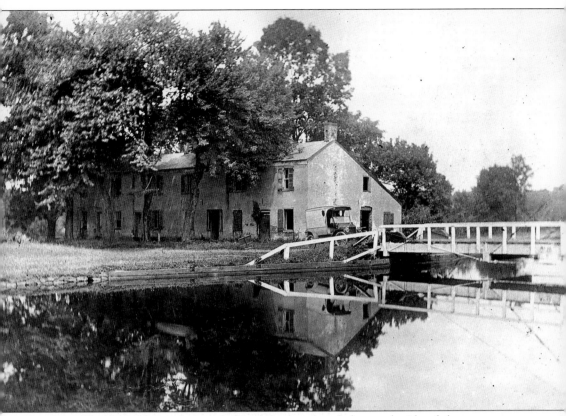

The Long House stands on the west side of the canal and the north side of the causeway. Although in modern times referred to as the Mule Tenders Barracks, recent research indicates that this structure was probably never used as a dormitory for either mill hands or mule tenders. Cornelius Simonson, for whom the brook in the rear of the property is named, probably built the Long House. In 1848, he sold the house and property to Abraham Veghte. At one time, the building served as a store and post office operated by Ann Veghte Edgar. There is speculation that the Long House may have been a grain-storage facility for the farms in the area, as it bears an uncanny resemblance to the grain house in Bernards Township.

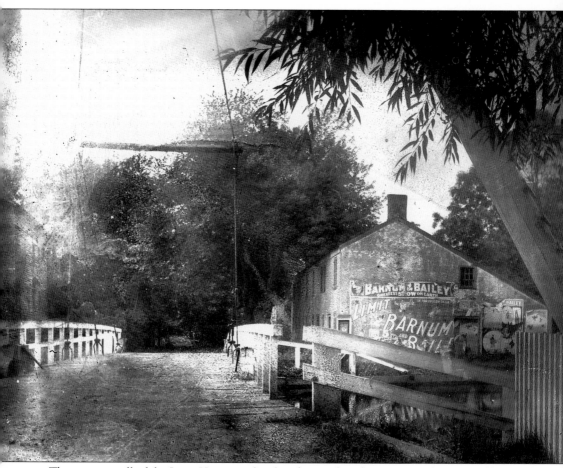

The eastern wall of the Long House made a handy spot for advertising, as this painted broadside indicates. Among the several signs is one that reads, "Barnum & Bailey, Greatest Show on Earth—The Limit of Human Daring." In the mid-20th century, the Long House was subdivided to create apartments. The building, once the largest interpretive center along the canal, housed the museum of the Griggstown Historical Society from the mid-1980s until 1999. In September of that year, the interior was severely damaged by the flooding that followed Tropical Storm Floyd. The state park system has developed a management plan for the Griggstown Causeway, its associated buildings, and Lock No. 9 and is planning to reestablish a museum in the Long House.

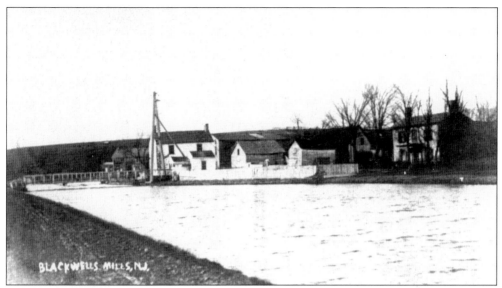

The Blackwells Mills bridgetender's house, seen just behind the A-frame, was one of many dwellings erected for the men and women who operated the swing bridges. The last bridgetender at Blackwells Mills was Sandor Fekete, a Hungarian immigrant who remained here long after the canal had closed. As a canal employee, Fekete's main job was to open and close the swing bridge. In addition, he kept the bridge in good repair and helped with the canal work as needed. The bridgetender and his wife lived here without benefit of plumbing or electricity. They grew grapes and tobacco for their own use. Local residents remember that Fekete and a friend would crush the grapes with their feet to make wine. Fekete passed away in 1970, at the age of 91. The Blackwells Mills Canal House Association has furnished the interior to show how a canal family lived in the 19th century.

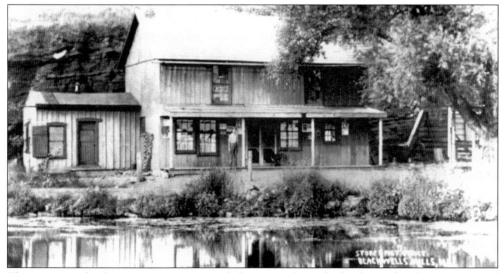

This structure, built in 1898, is just around the corner from the bridgetender's house on Canal Road. It served as the Blackwells Mills Post Office and a general store until 1934. Since 1953, the building has been privately owned.

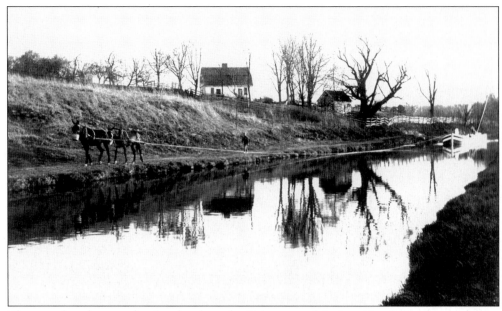

There are few photographs of mules along the Delaware and Raritan Canal. If a captain did not have his own team, mules could be rented for $6 per trip from the stables in Bordentown, Trenton, Kingston, and New Brunswick. Usually, the children in the family served as the mule drivers, but a captain could hire a youngster if he had no children. In this photograph, the mule driver is walking quite a bit behind his animals. He may have stopped to speak with the captain and is now trying to catch up to the team.

East Millstone was a busy community during the canal era. The Olcott brothers built a flax and husk mill in 1846, converting it to a distillery in 1858. In 1880, Gaff & Fleischmann purchased the business (right). The refuse grain from the distillery provided feed for the family's beef cattle. In the 1880s, Maximillian Fleischmann bought an estate, downstream of East Millstone, but died shortly thereafter. His family sold the distillery but continued to live on the estate, now the grounds of Somerset County's beautiful Colonial Park. You can visit Mrs. Fleischmann's famous rose gardens and the stables where the family kept their fine horses.

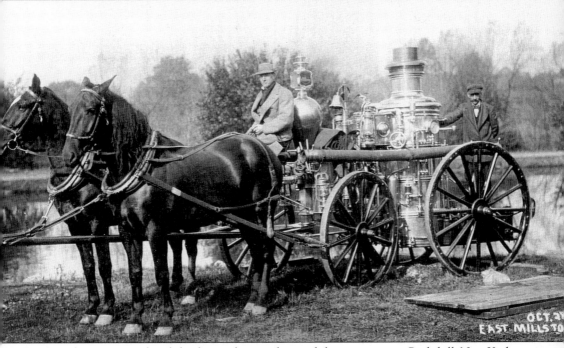

In 1910, the company closed the factory here and moved the operation to Peekskill, New York. The site was sold to the Harmer Rubber Reclaiming Works. A major fire destroyed the business in October 1912. To fight the fire, local companies used their pumpers and drew water from the canal. The men of the Somerville Fire Company, pictured here, arrived too late to be of assistance, which explains their clean and neat appearance. Their pumper is preserved in the Somerville Fire Museum. The Harmer works was rebuilt and was later known as Somerset Rubber Company, Somerset Rubber Reclaiming Works, and Laurie Rubber Reclaiming.

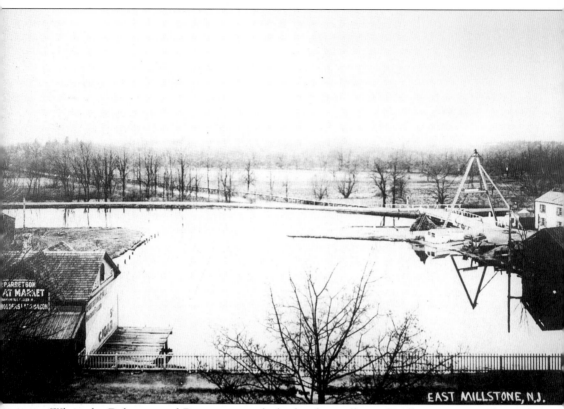

EAST MILLSTONE, N.J.

When the Delaware and Raritan opened, the bustling village of Millstone was on the wrong (west) side of the Millstone River. Its wheat had to be transported to the east side for pickup by canalboats. A commercial center, originally called Johnsville but later changed to East Millstone, grew around the canal, as farm products where shipped out and coal and other goods brought in. A large basin, seen in the foreground, provided room for this commercial activity without blocking the flow of traffic.

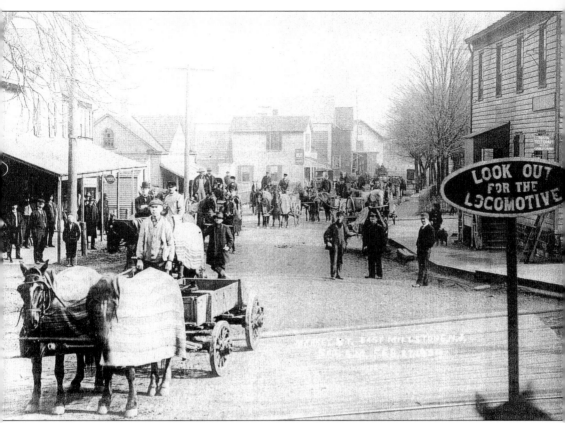

In East Millstone, the stores along the west (left) side of its bustling Market Street backed up to the canal. Those at the northern end of the street were adjacent to the basin. The many wagons and shops clearly show the importance of East Millstone as a stop along the canal. In the foreground are the tracks of the Millstone and New Brunswick Railroad.

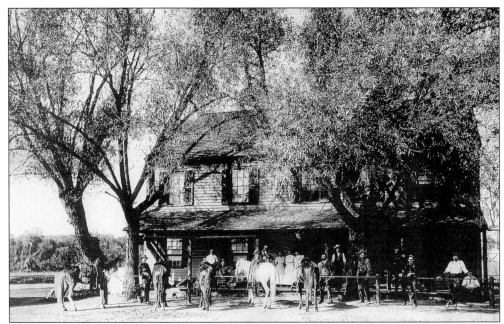

Believed to be the oldest structure in East Millstone, the Franklin Inn was originally the Van Liew farmhouse. In the early 19th century, it was remodeled into a tavern called the Franklin House and, later, the Franklin Inn. During the canal era, it was a stopover for canal workers, boatmen, and traveling salesmen. Known to be a bit of a rowdy place, the inn at one time was managed by a man named Holtsizer. He had lost a hand and wore a hook in its place. It is said that he kept order by plunging the hook down onto the bar within an inch of an unruly customer. Today, the inn serves as a used bookstore, operated by the Meadows Foundation.

As heavier vehicles began to cross the canal, A-frame bridges were gradually replaced by the stronger king-post construction. The canal company sent its own carpenter crews to build the new spans. They lived on the workboat if they were too far from their base in Trenton. The East Millstone bridge was replaced in 1913.

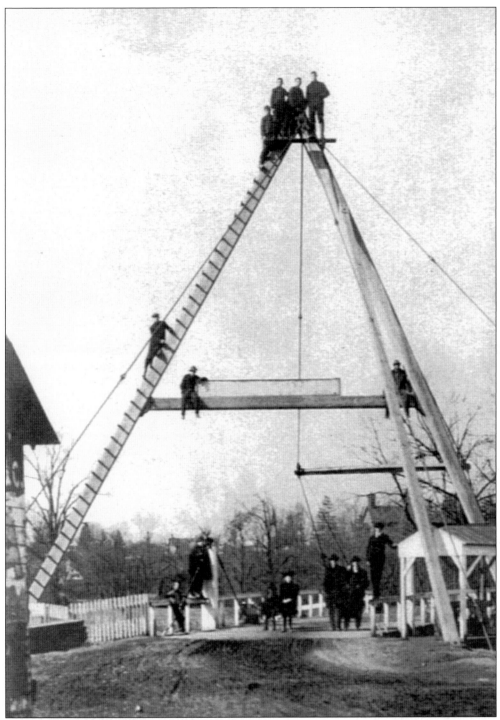

In this delightful picture, it is easy to see the size of the A-frame superstructure. Amidst the people posing, one can see the rigging of the bridge and the shed covering the winch mechanism. After stopping the vehicular traffic, the bridgetender cranked open the bridge by means of a winch connected to a cable through a pulley to the bridge.

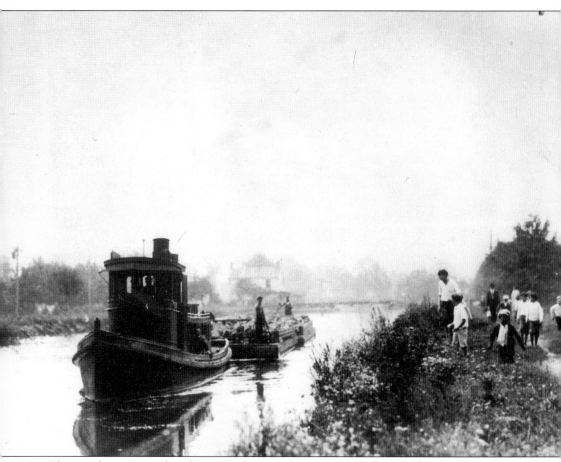

The canal was a popular place. People were drawn to its banks, whether for fishing, to help swing the bridge, or just to watch the boats. Vessels from all along the East Coast passed through the small canal towns, bringing a taste of faraway places to the local residents. These folks have gathered to get a closer look at the steam tug *Relief*, towing a barge along this quiet stretch at Zarephath. Built in 1884, the *Relief* was used as the pay boat and as an icebreaker when needed.

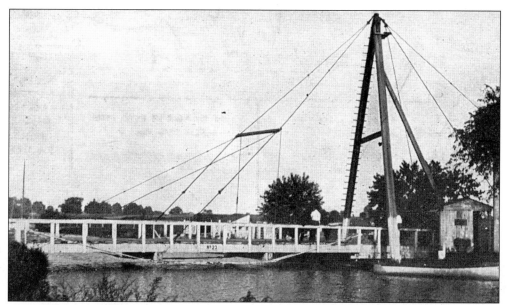

The religious community of Zarephath, started in 1906 by Alma White, owns 500 acres in Franklin Township on both sides of Weston Canal Road. Known as the Pillar of Fire, it is a training center for ministers and missionaries and the home of a gospel radio station, WAWZ. The name Pillar of Fire comes from a Bible story about Moses leading the people of Israel through the wilderness; a pillar of fire guided them at night. To prevent flooding from the Millstone, a dike, or berm, completely surrounds the village of Zarephath. The dike was raised after it was overtaken by the river in 1972. The flooding from Tropical Storm Floyd in 1999 eclipsed the new dike, however, causing serious loss of property in the village.

In 1911, the Pillar of Fire purchased a sailboat, the *Idler*. After removing the sail and installing an engine, the residents rode between the village and South Bound Brook, passing through Lock No. 10. Missionaries from the Pillar of Fire Temple in Bound Brook could walk across the Raritan River to South Bound Brook and board the boat for the ride to Zarephath. The boat served the community for two decades, but, in this picture, perhaps it is a bit overcrowded.

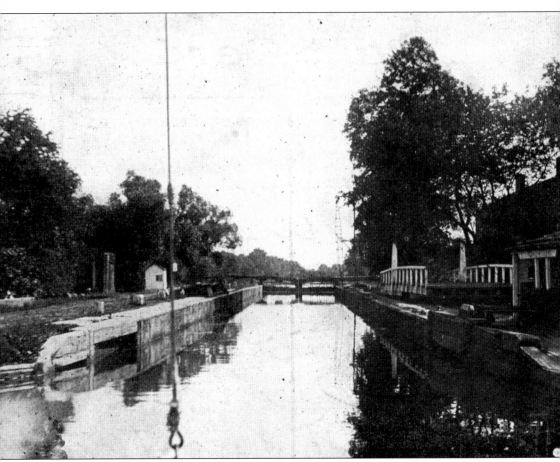

Just downstream of Zarephath is Lock No. 10, or Ten-Mile Lock. The swing bridge on the side allows the locktender to reach the opposite side of the lock. Just out of the picture, to the left, is the Millstone River. At the confluence of the Millstone and the Raritan, the Elizabethtown Water Company has built two pumping facilities to take water from both rivers and the canal.

This is a rare close-up view of the miter gates at the lower end of Lock No. 10, near Zarephath. The bridge shown permitted the locktender to cross the open lock and was lifted out of the way for the passage of vessels. When the canal was rehabilitated to become a water supply system, the miter gates and the drop gates were removed. Concrete dams with sluices replaced the upstream gates to allow the water authority to control the flow of water.

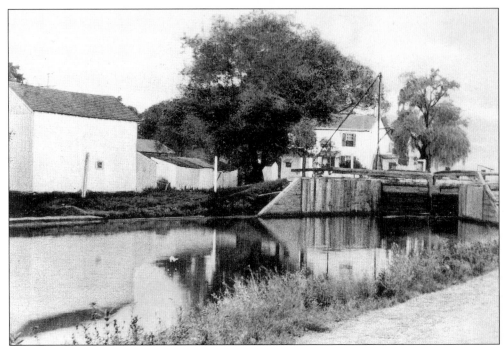

This view, looking upstream, shows Lock No. 11 at South Bound Brook, a town that was forever changed by the arrival of the Delaware and Raritan. Stables, wharves, and grain-storage warehouses were built and new streets were laid out. Some of the Irish families who had come to work on the canal lived in a section of town called Dublin.

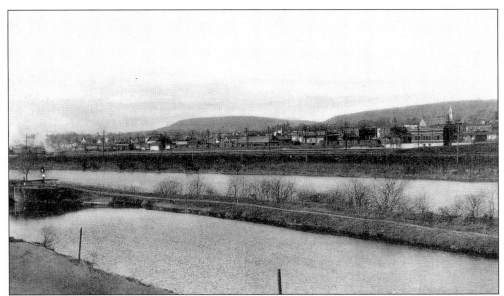

Here the Raritan River flows between Bound Brook, at the top of the photograph, and South Bound Brook. The latter, known for a time as Bloomington (1869–1891), became a busy freight port on the canal. The towpath is, in effect, a dike, separating the canal from the Raritan River. The hills beyond are the Watchung Mountains. On the far left we can see the balance beam of the miter gate.

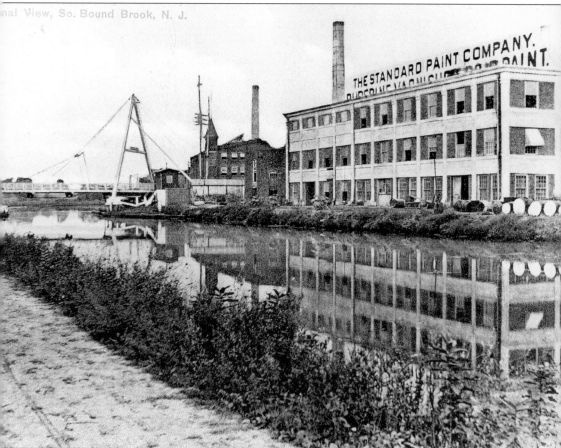

One of the most notable businesses was the Shurts Shipyard, which produced steam-propelled vessels 150 feet long, each with a 23-foot beam. Both the Somerset Steam Saw Mill Company and the Israel Codington & Company Steam Saw Mill abutted the canal, along with L.D. Cook's Lumber Yard. Jacob Shurts sold grain and coal near the bridge. In 1887, the Standard Paint Company (shown) was built on the site of the old lumberyard; it extended along the canal both upstream and downstream of the bridge. The borough of South Bound Brook plans to redevelop this area and create a new business-residential complex, using the canal as the centerpiece.

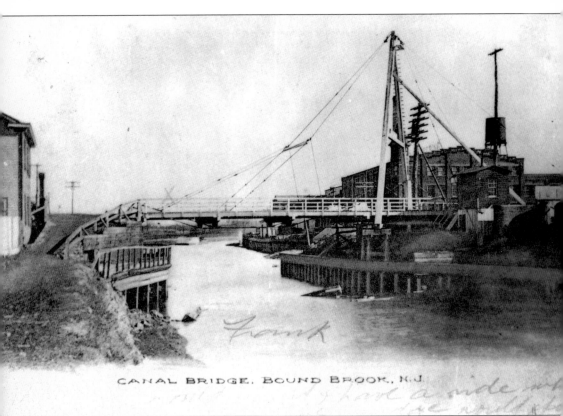

CANAL BRIDGE, BOUND BROOK, N.J.

Postcards, such as this one, sometimes contain errors. While the town of Bound Brook is off to the left across the Raritan River, the canal itself is located in South Bound Brook. The walkway under the left side of the bridge allows the mules to pass under the span without unhitching the lines. Although this is now a fixed bridge, the swing mechanism can still be seen underneath the roadway. The bridgetender's hut, on the right, was used as a shoe repair shop during the author's childhood, long after the canal had closed. The buildings on the towpath no longer exist. To reach the larger town of Bound Brook, people traveling the canal could cross the swing bridge and the Queens Bridge over the Raritan River. The Bound Brook Hotel was a favorite watering hole for boatmen and local residents alike.

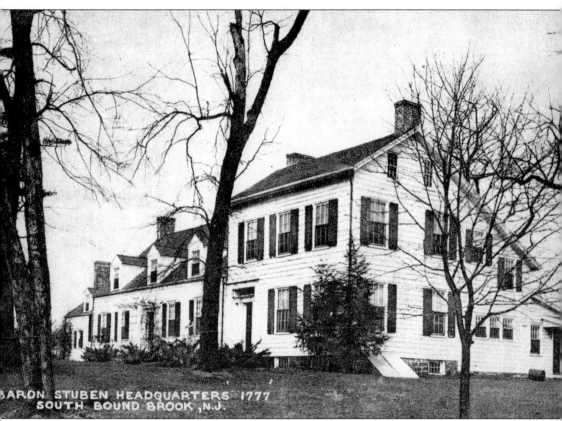

BARON STUBEN HEADQUARTERS 1777
SOUTH BOUND BROOK ,N.J.

The canal curved around South Bound Brook, passing boatyards, lumberyards, and dealers in grain and coal. As the boatmen headed down the last few miles toward New Brunswick, they passed the home of Abraham Staats. In March 1779, during the Revolutionary War, Staats offered his home as the headquarters for Baron Von Steuben, who had come to train nearly 10,000 soldiers at the second Middlebrook Encampment. In May of that year, Von Steuben reviewed eight regiments in honor of General Washington and the visiting French minister. Staats's slave, Tory Jack, was thought to have spied on the British in New Brunswick and reported their activities to his master, a prominent patriot. The building, now owned by the borough of South Bound Brook, is a museum of Revolutionary War and local history.

Just beyond the Staats House is Lock No. 12. As at the other locks, there is a lift bridge across the downstream end of the lock to allow the locktender to cross the lock and work on the other side. Just upstream of the lock is a wide-water area in which boats could tie up or turn around more easily.

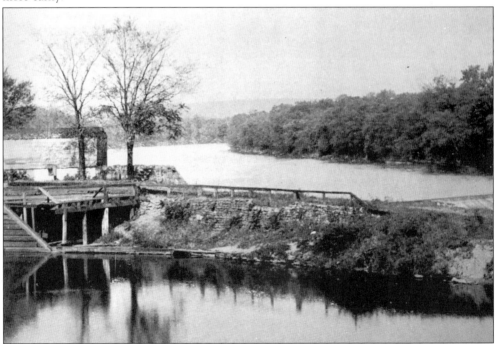

The Delaware River supplied most of the water for the Delaware and Raritan Canal. For the last five miles, however, the water supply was supplemented by an intake from the Raritan River to help meet water-power needs in the New Brunswick area. Here, at the Fieldville Dam (far right), water was diverted through the culvert on the left. It entered the canal just downstream of Lock No. 12.

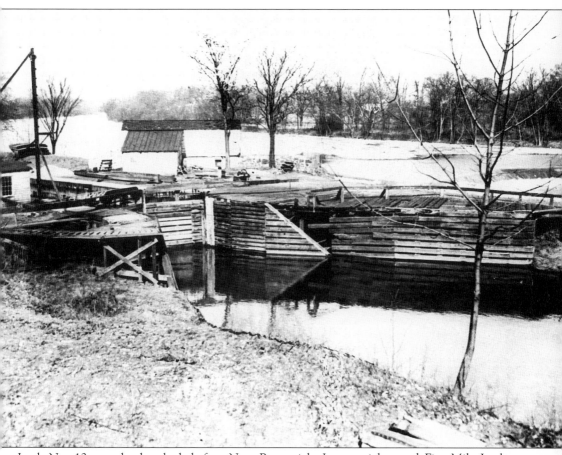

Lock No. 12 was the last lock before New Brunswick. It was nicknamed Five-Mile Lock, although it is actually closer to six miles from the end of the canal. The treads in the walkway, at the balance beam, gave the locktender better traction as he opened or closed the gates. The Fieldville Dam can be seen on the right in the Raritan River.

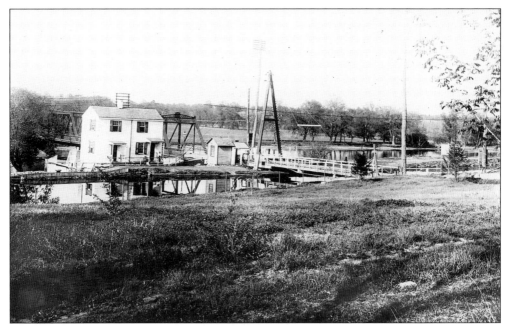

The Landing Lane Bridge carried vehicular traffic across the canal to access the bridge over the Raritan River. Across the river, on the Piscataway side, was the prosperous Dutch shipping port of Raritan Landing. In the 1700s, the landing was the farthest point up the Raritan that a seagoing vessel could reach. Ships were off-loaded and their cargo was carted to the communities upstream in the Raritan Valley. When the canal opened, it provided a faster, cheaper way to deliver goods inland. As a result, business at Raritan Landing gradually decreased.

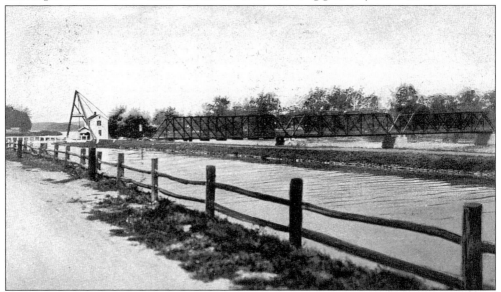

The present Landing Lane Bridge is one of the few spans that still has the swing mechanism underneath. The steel-beamed road and railroad bridges in South Bound Brook, as well as the Princeton dinky bridge, also have the motor, pivot, gearing, and the wheels that ran on a circular rail as the bridge turned. This newest version replaced the original swing mechanism on the old wooden bridges.

Four

The Northern Terminus: New Brunswick

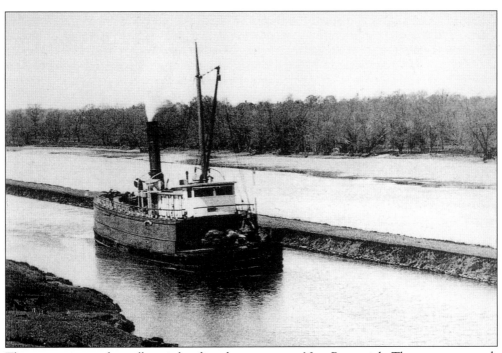

This steam-powered canalboat is heading downstream to New Brunswick. The narrow towpath serves as a dike or dam to protect the canal from the Raritan River. In times of flood, the Raritan did overflow into the canal, in some places eroding the towpath.

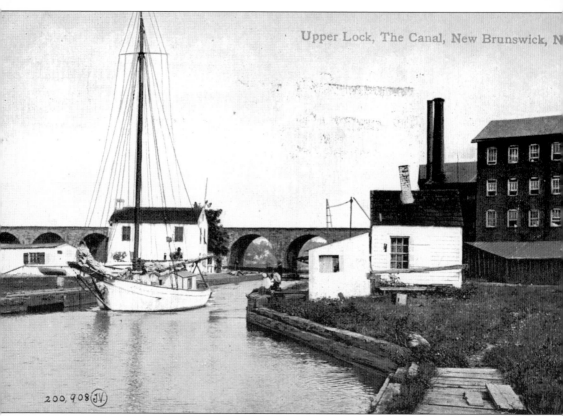

This sailboat is heading upstream, having just left Lock No. 13, Deep Lock. Although it did not really have the greatest lift of all the locks on the Delaware and Raritan Canal, Deep Lock did raise and lower the boats just over 12 feet. Behind the sailboat is the bridgetender's home. The home is shown again on page 123, pictured after the canal was closed. The Johnson & Johnson factory buildings can be seen on the right. In the background is the bridge carrying the Pennsylvania Railroad over the canal and the river. This same bridge now carries Amtrak and New Jersey Transit trains.

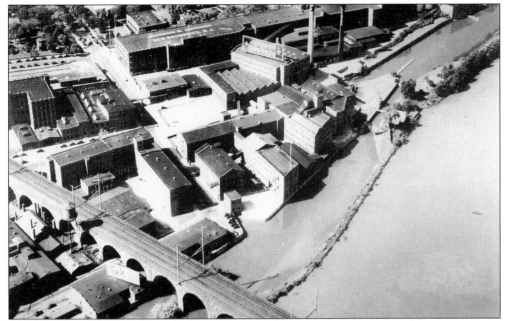

This aerial view shows Lock No. 13, Deep Lock, where the canal entered the busy port of New Brunswick. The canal towpath was constructed in the Raritan River, seen in the lower right. In this photograph, taken long after the canal closed, the towpath is overgrown with trees and bushes. The huge Johnson & Johnson plant abuts the waterway. This lock and a section of the canal were destroyed in the late 1970s during the construction of Route 18.

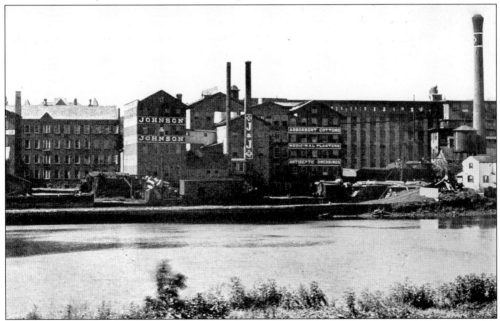

Just downstream of Deep Lock, a factory district fronted on the canal. The building on the left is the Norfolk and New Brunswick Hosiery Company. Johnson & Johnson, the complex on the right, advertised its products on the wall: absorbent cotton, medicinal plasters, and antiseptic dressings. This view was taken from the Livingston Manor, across the river.

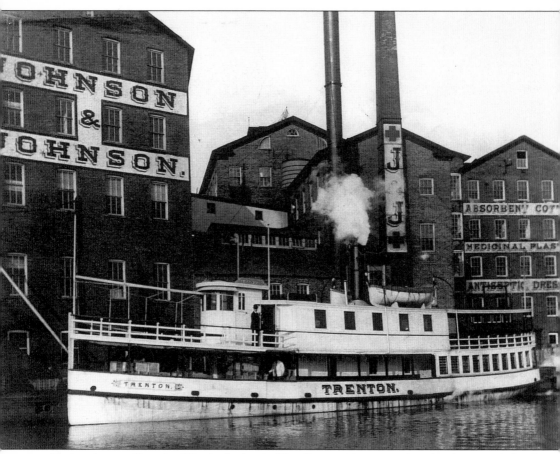

During the canal's active life, the harbor in New Brunswick was much wider than it is today. It was a busy port with shipyards, chandleries, and factories. One of the major businesses was Johnson & Johnson, the pharmaceutical company. Today, 70 years after the canal closed, Johnson & Johnson still has its headquarters next to the canal. The company had its own fleet of boats, operating as the Middlesex Transportation Company. The *Trenton*, built in 1859, is seen loading freight in this *c.* 1902 view.

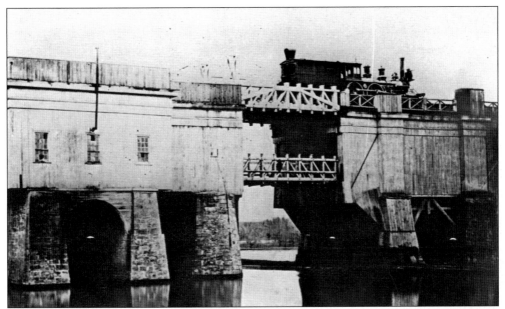

The Camden & Amboy Railroad originally crossed the river and the canal on this bridge, built in 1839. Notice its unique double-deck feature: the upper crossing is for the trains, and the lower one is for pedestrians and vehicles. The section over the canal had a draw mechanism to allow clearance for all high-masted vessels. Taken in 1866, the photograph shows a Camden & Amboy locomotive. In 1867, the Joint Companies combined with the New Jersey Railroad and Transportation Company to form the United New Jersey Railroad and Canal Company.

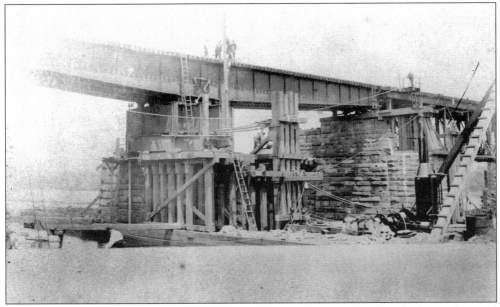

Later in the 19th century, the Pennsylvania Railroad replaced the wooden bridge with a steel structure. When the present stone-arch bridge was completed in 1903, this steel swing span was moved south to bridge the Rancocas Creek between Delanco and Riverside, New Jersey. It lasted until 2001, when it was replaced by a fixed bridge for the new Southern New Jersey Light Rail Transit System.

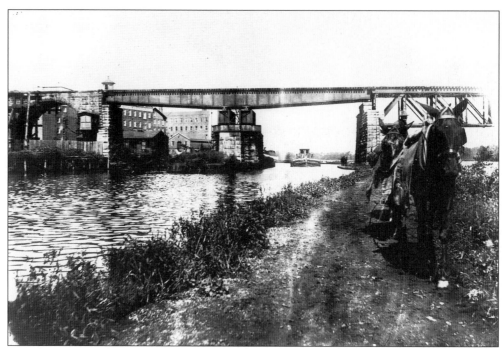

This vessel has just left Deep Lock and is passing under the new steel swing bridge that replaced the double-deck drawbridges. Notice that the mule driver is riding on the second mule; usually he or she walked next to the team.

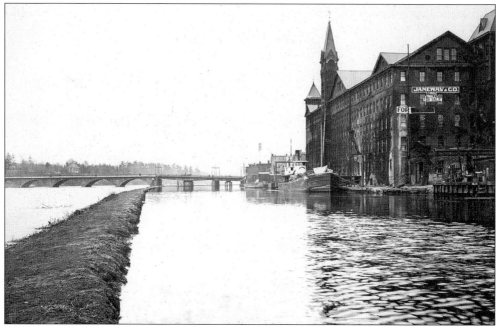

We have just passed under the railroad bridge and are proceeding downstream toward the Albany Street bridge, seen in the distance. The towpath looks narrow, but it is actually between 10 and 12 feet wide. The building on the right is Janeway and Company Inc., a wallpaper manufacturer. It was for sale at the time this photograph was taken, January 6, 1916.

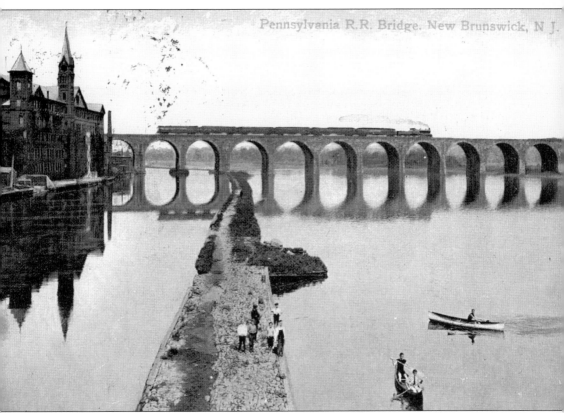

Looking back, we see the stone-arched bridge, completed in 1903 by the Pennsylvania Railroad, to cross the Raritan River and the Delaware and Raritan Canal. From this time on, only vessels with a clearance of 50 feet or less could use the canal. This postcard also shows the width of the towpath and people enjoying the waterfront. The reflection of the bridge pier gives the optical illusion that the pier separated the canal and the towpath. Here in the New Brunswick area, the towpath was constructed of wooden cribbing, boxlike structures made of heavy timbers filled with rubble stone and covered with dirt. This strong support system has held fast for 170 years.

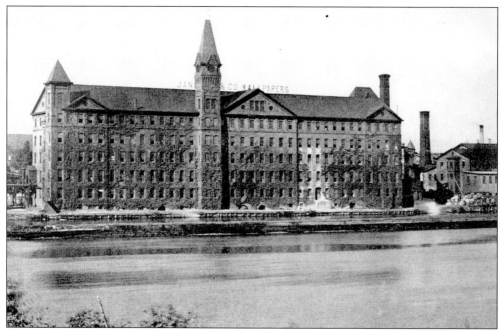

This view of Janeway and Company Inc. was taken from the Livingston Manor, a Victorian mansion across the river in Highland Park. At one time, Janeway was the largest wallpaper manufacturer in the United States. It was destroyed by fire in March 1907 and rebuilt. This photograph was part of an advertising booklet aimed at selling properties in a new development to be named for the mansion.

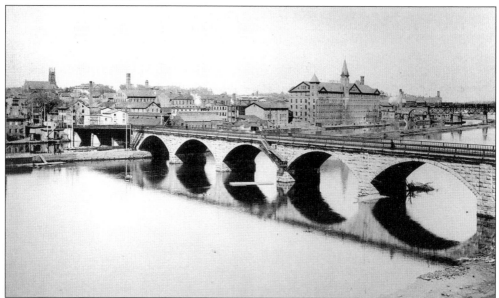

In this view looking upriver from Highland Park, the Albany Street bridge crosses the river and the canal. To the right is the Janeway & Company building. Albany Street is now Route 27, a state highway that connects Princeton and Elizabeth. It was part of the old King's Highway and later, the Lincoln Highway. For many years, trolley cars, including those of the Public Service Railroad Fast Line between Newark and Trenton, used this bridge.

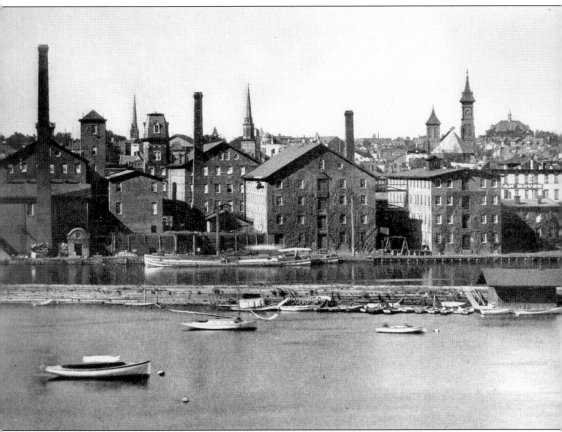

Another factory district developed downstream of Albany Street. It included the United States Rubber Company, in the center of the photograph. Many of the factories on the New Brunswick harbor operated by water power supplied by the canal. The canal company charged rent for the use of this water. While the canal was deep enough to accommodate small seagoing vessels, the river in New Brunswick was quite shallow. Usually only the smaller boats, such as those in the foreground, could navigate the river.

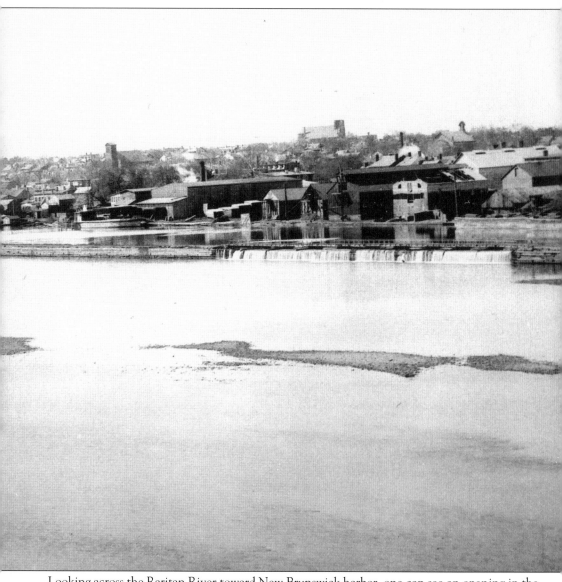

Looking across the Raritan River toward New Brunswick harbor, one can see an opening in the towpath. It resembles a waterfall. This is the waste weir, designed to allow excess water to flow into the river. The additional water was runoff from the city's storm sewers; it entered the canal near this point. The canal company built a bridge over the weir to allow the mule teams to cross. During the restoration of the double outlet locks in 1998, it was suggested that a replica mule bridge be placed across the weir to make the towpath continuous. Instead, two modern bridges now cross the canal to bypass the weir.

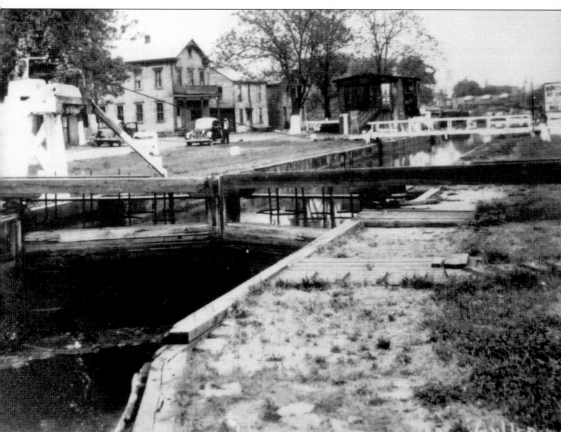

In 1868, Chief Engineer Ashbel Welch installed a mechanical mule at each lock to speed up the locking process. A small steam winch engine turned a three-foot drum. The drum powered a wire rope that passed around sheaves above and below the lock. The vessels were attached by short lines to the wire rope and pulled into and out of the chamber. Today, at the double outlet lock restoration in Boyd Park, one can see the foundation for the powerhouse for the mechanical mule.

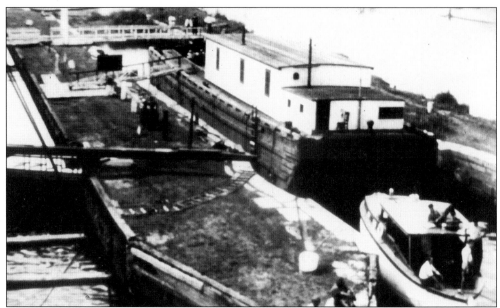

In this close-up view of Lock No. 14, the outlet locks, a large vessel is moored in the outboard, or sloop, lock, which was not in use at the time. (The outboard lock is the one closest to the river.) To push the balance beam and open or close the gates, the locktender walked along the treadway for extra traction. In 1998, the city of New Brunswick restored the double outlet locks, creating the only working locks in the state. This project was mitigation for the destruction of Lock No. 13 and the adjoining section of the canal when Route 18 was constructed.

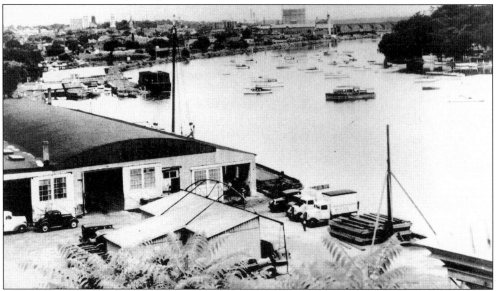

Looking upstream from Sonaman's Hill, this photograph shows the northern terminus of the Delaware and Raritan Canal. Originally there was a single outlet lock, 30 feet wide, but the engineers soon realized that two locks would reduce the waiting time. In 1866, under the direction of Chief Engineer Canvass White, the second, or inboard, lock was constructed. The swing bridge allowed the mules to reach the stables on the land side of the lock. This lock remained in use for a few years after the canal closed, allowing boats to reach the harbor.

Five

THE FEEDER

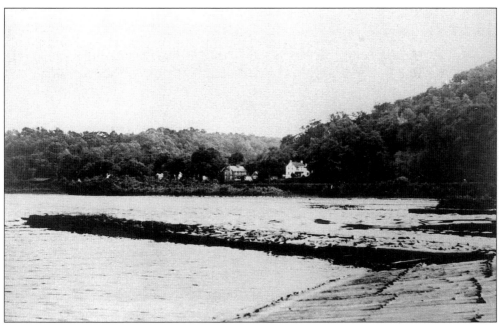

When engineers are planning the construction of a canal, their most important consideration is a source of water. For the Delaware and Raritan Canal, that source was, and still is, the Delaware River. At Bulls Island, or Raven Rock, a wing dam, shown during low water, diverts Delaware River water into the feeder canal. The water passes through a guard lock and begins its journey of 22 miles south to Trenton and the main canal.

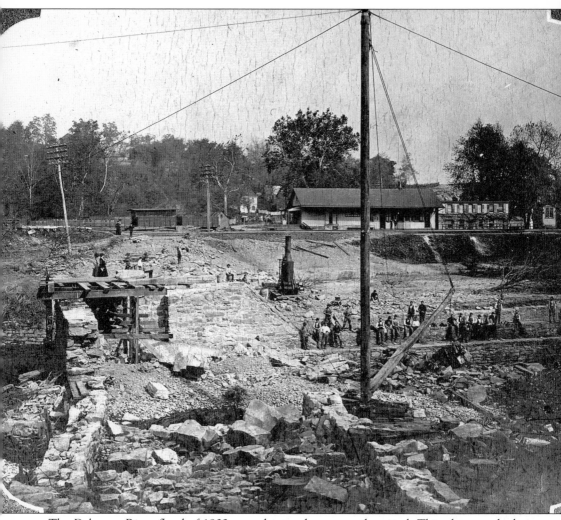

The Delaware River flood of 1903 caused great damage to the canal. This photograph shows repairs being made to the guard lock at Bulls Island. The tall wooden mastlike structure is a crane that aids in lifting heavy loads into place for the reconstruction. The crane was powered by the stationary steam engine to the left of the pole. The Belvidere-Delaware Railroad Station is in the background. Today, Bulls Island is the site of the only campground in the Delaware and Raritan Canal State Park. It features a lovely pedestrian suspension bridge that crosses the Delaware River to Lumberville, Pennsylvania.

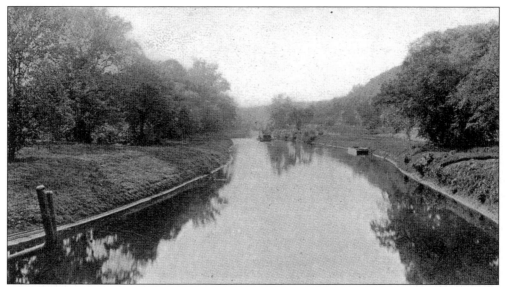

Smaller than the main canal, which is 75 feet across and 8 feet deep, the feeder is 60 feet across at the surface and 6 feet deep. It parallels the river all the way to Trenton and was navigable during the canal's lifetime. The former right-of-way of the Belvidere-Delaware Railroad now serves as a multipurpose trail.

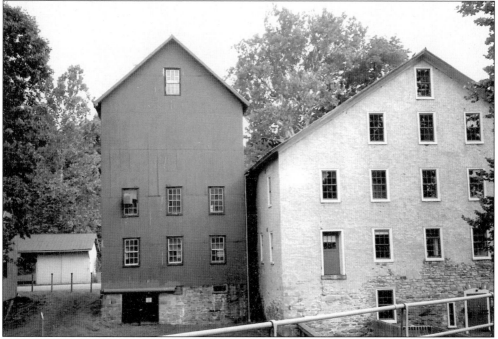

The Prallsville Mill Complex, north of Stockton, is the home of the Delaware and Raritan Canal Commission. The four-story stone gristmill was built in 1877 on the foundation of the original mill. The first mill burned when sparks from a passing locomotive set fire to the covered railroad bridge across the Wichecheoke Creek. The fire destroyed the bridge and the mill. The building on the left is the grain silo, built in 1890. The current bridge, from which the photograph was taken, is seen in the foreground.

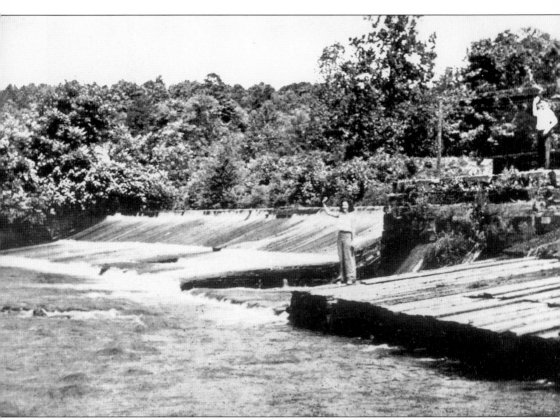

Next to the Prallsville Mill Complex, the Wichecheoke Creek flows directly into the Delaware and Raritan. On the opposite bank, the water overflows the canal, spilling over a waste weir into the Delaware River. After a heavy rain, the overflow may resemble a waterfall, as it does in this postcard. Usually, side streams did not flow directly into the canal but were diverted under it in culverts. Just downstream is the Prallsville guard lock, constructed to protect the canal against the flooding of the Delaware River.

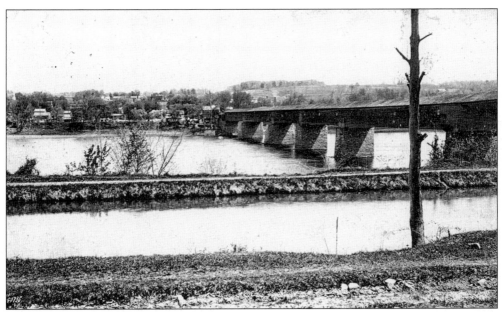

Bridge Street, the main street of Stockton, crosses the canal, the Belvidere-Delaware Railroad, and the Delaware River. Originally, a ferry service called Howell's Ferry, among other names, took passengers across the river from Stockton to Centre Bridge, Pennsylvania. After the completion of the Centre Bridge in 1814, the ferry was abandoned. The iron bridge that crosses the river today opened in 1927, replacing the covered wooden bridge (pictured) that burned in 1923.

Unlike many towns along the Delaware and Raritan, Stockton did not feel the dramatic impact of the canal on its economy. Few vessels came this far north, as the last major manufacturing center was south of town, at Brookville. In addition, the waterway passed west of the main business district. So, to most residents of Stockton, the canal feeder was just that, a conduit taking the water to the main canal in Trenton.

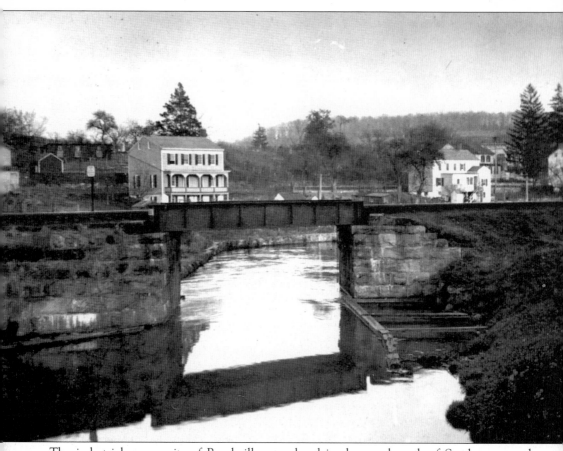

The industrial community of Brookville, at a bend in the canal south of Stockton, was the upstream terminus for mule-drawn boats. John Deats, of Stockton, invented the Deats plow in 1828. His son, Hiram, made stoves, kettles, school desks, and much more at his factory in Quakertown. At Brookville, from 1852 to 1881, Hiram operated a blacksmith shop and a foundry that produced the Deats stoves, plows, and other farm machinery. The towpath was extended from Lambertville to Brookville to supply the Deats industries. The Belvidere-Delaware Railroad crosses the canal at Brookville and remains on the right bank all the way to Trenton.

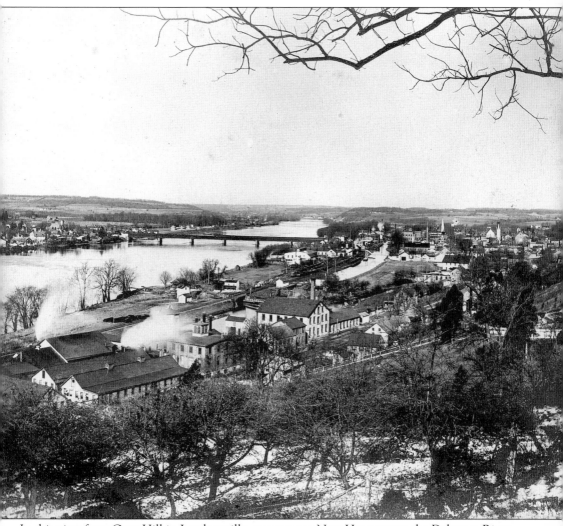

In this view from Goat Hill in Lambertville, one can see New Hope across the Delaware River in Pennsylvania. The Delaware Canal, which ran from Easton, Pennsylvania, to Bristol, Pennsylvania, parallels the west bank of the river. Along the eastern shore, the balance beams of the Lambertville outlet lock can be seen at the northern end of the line of trees. Boats from Pennsylvania crossed the river by using a cable ferry and entered at this lock. The vessels then passed under the railroad bridge and made a 90-degree turn into the feeder. Farther north on the canal is the pedestrian bridge at the railroad shops.

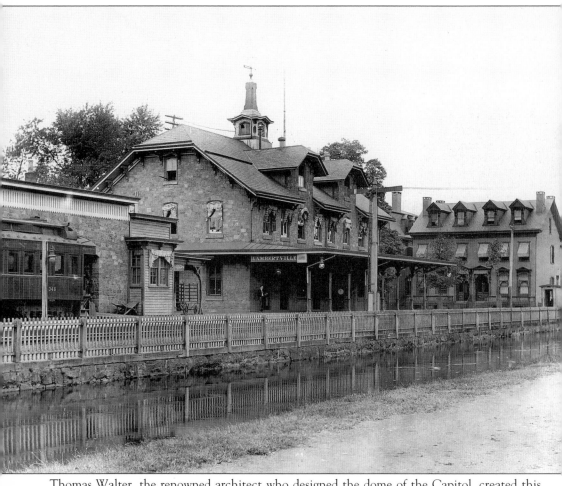

Thomas Walter, the renowned architect who designed the dome of the Capitol, created this imposing two-and-a-half-story stone station. Completed in 1867, the building was the Belvidere-Delaware Railroad Station, primarily serving passengers traveling to and from Trenton. In the late 18th century, the Pennsylvania Railroad took over the line and instituted service to New England. In 1982, the current owners purchased the building and renovated it, preserving what could be saved. The exterior was restored to its original beauty. In recent years, excursion trains of the Black River & Western Railroad have served the station. The feeder canal is in the foreground.

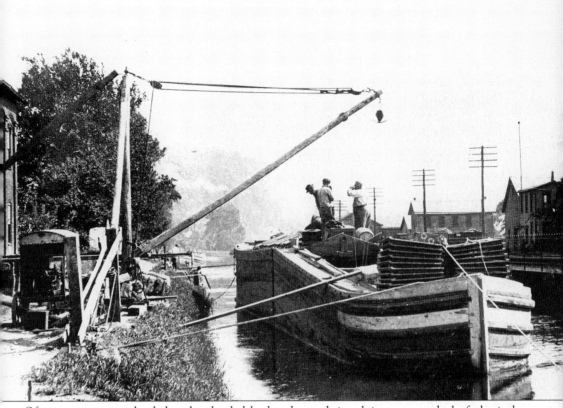

Often, cargoes were loaded and unloaded by hand, a task involving a great deal of physical labor. Some businesses, like the Perseverance Paper Mill in Lambertville, used a gasoline-engine-powered boom to ease the work. Piled on the bow of this canalboat are the hatch covers, placed there to be out of the way during the loading process. A keen eye may spot a stove and a water barrel where the workmen are standing. The vessel is a Lehigh Coal and Navigation section boat, but without the distinctive bull's-eye logo of that firm.

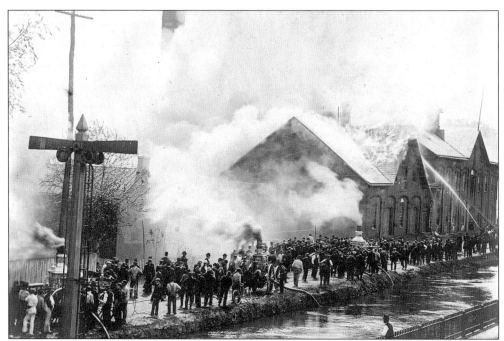

In 1923, a fire destroyed the Perseverance Paper Mill. In this picture, three steam pumpers are working hard to draw water from the feeder to fight the fire. The photographer was leaning out of a window on the second floor of the Belvidere-Delaware Railroad Station.

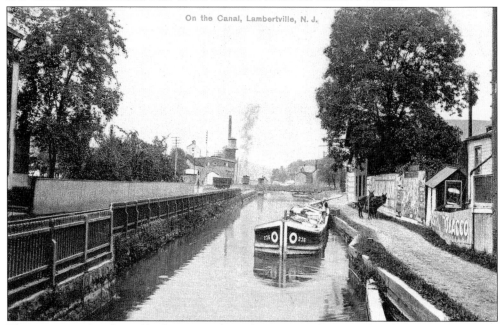

This scene in Lambertville features a boat from Pennsylvania. The distinctive bull's-eye insignia denotes a vessel from the Lehigh Coal and Navigation Company, which operated boats along the Lehigh Canal from the coal fields to Easton. Vessels could then proceed south on the Delaware Division Canal to the outlet at New Hope or continue to Bristol, Pennsylvania. Prior to 1894, canalboats could cross the Delaware River at Phillipsburg to access the Morris Canal.

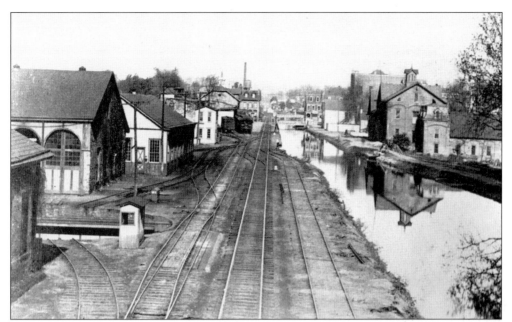

South of the business district of Lambertville, the Belvidere-Delaware Railroad shops serviced the cars and locomotives. On the right side of the canal, you can see the cupola of the Perseverance Paper Mill. This view was taken from the pedestrian bridge that spanned the tracks. Today, although the railroad shops are gone, the track remains on the original towpath. Note the railroad turntable, left of center.

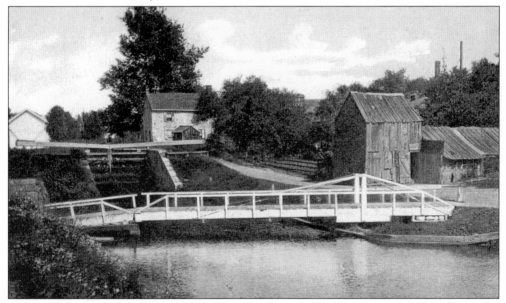

The Lambertville lock had a lift of 10.5 feet. In this view, looking upstream, the basin in the foreground allowed boats to make a 90-degree turn to pass under the Belvidere-Delaware Railroad (to the left, out of the picture) and enter the outlet lock, which was perpendicular to the feeder canal. The swing bridge provided a route by which the mules could cross the feeder and tow the boats to the outlet lock. The mules were then unhitched and walked across the Lambertville-New Hope bridge.

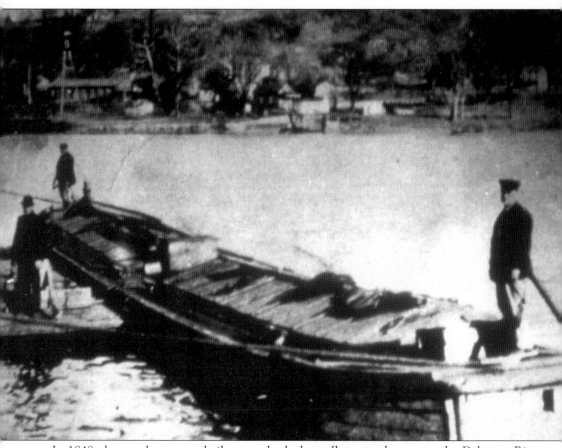

In 1848, the canal company built an outlet lock to allow vessels to cross the Delaware River between New Hope, Pennsylvania, and Lambertville, New Jersey. A cable was suspended from a single tower on each side of the river; from it were hung two cables on pulleys to attach to the bow and stern of the canalboat. The force of the river's current drove the angled boat across the river. Often "Chunkers," boats that had descended the Lehigh Coal and Navigation from the coal center of Mauch Chunk, entered the feeder through this lock. Upon reaching Easton, at the end of the Lehigh, boats proceeded south on the Delaware Division Canal to New Hope and crossed the river here.

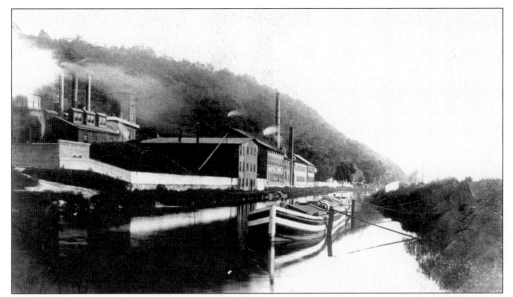

South of the city, the Lambertville Rubber Company used the canal to transport its products. Since the factory required coal and water, its location along the canal was ideal. Over the years, the company continued to expand its operation, adding several more buildings. Today, these buildings house offices and retail shops. This boat is tied up on the berm side of the canal, leaving room for passing vessels.

Again we see a misnomer, as this postcard identifies the canal as the B & R. Note that the card was published by the Doll Hospital, whose expertise was perhaps not in canals—that may explain the error. The Delaware River is seen to the right of the Belvidere-Delaware tracks. The endless line of telegraph poles parallels the canal.

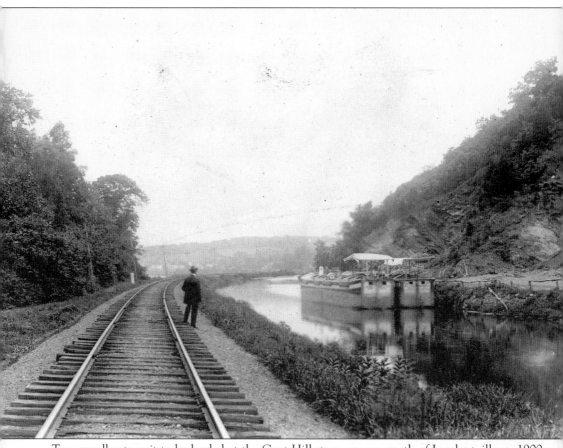

Two canalboats wait to be loaded at the Goat Hill stone quarry, south of Lambertville, c. 1900 while a well-dressed gentleman surveys the scene. Several quarries along the Delaware River produced brownstone for new buildings in Trenton, Philadelphia, and New York City. Roads in those cities were also paved with stones brought by boats on the Delaware and Raritan Canal.

The Belvidere-Delaware line became an important freight route to New England for the Pennsylvania Railroad. Long trains were moved to Phillipsburg, where the Lehigh and Hudson River Railway took them to Maybrook, New York. There, the New Haven Railroad hauled them over the Poughkeepsie Bridge to New England.

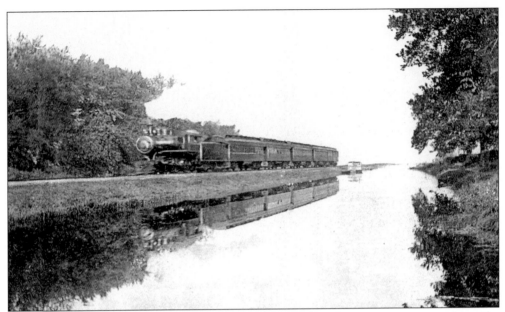

Paralleling the Delaware River, the feeder canal was dug to bring river water south to the summit level of the main canal in Trenton. The Belvidere-Delaware Railroad, built between 1850 and 1854, chose the same route. The railroad was constructed on the original towpath of the canal feeder, requiring a new path for the mules on the opposite, or berm, side. The new path was very narrow and not level. Today, the park's visitors use the railroad bed for walking, jogging, or biking. This view was taken near Firman's Bridge in West Amwell Township.

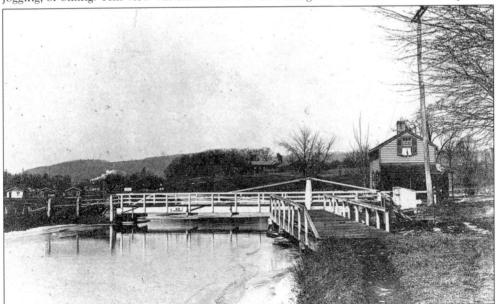

A section of Titusville, just north of Washington Crossing, became an island when the canal was built. With the river on the west and the canal on the east, residents used the swing bridges to travel across the canal. Farmers from the area brought their produce by wagon to the canal here, for shipment to Trenton. A king-post bridge and the bridgetender's house are seen in the background. The bridge on the right allows the mules to cross an incoming stream.

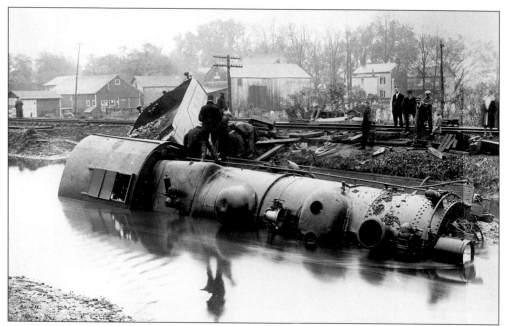

On November 3, 1928, this mail train, using the Belvidere-Delaware portion of the Pennsylvania Railroad, derailed at Titusville. The locomotive landed in the canal, and the mail was a little late that day. Canal traffic was delayed until the engine could be hauled out of the waterway.

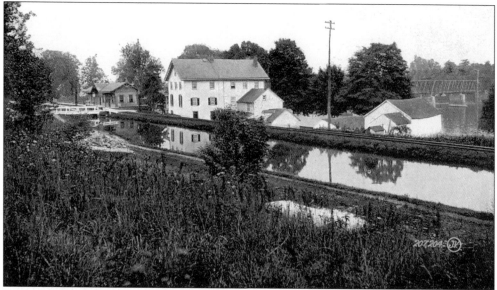

Washington Crossing was so named because this was the location at which George Washington and the Continental Army crossed the Delaware on Christmas night 1776 to attack the Hessians the next day in Trenton. Every year on Christmas Day, volunteers reenact the crossing using the Durham boats from the Washington Crossing State Park in Pennsylvania. The museum on the New Jersey side features many artifacts from the Revolutionary War period. This section of the Delaware and Raritan Canal State Park is a popular starting place for bikers and hikers. Notice the railroad station by the canal bridge and the iron bridge across the Delaware River.

It is important to maintain the same water level in the canal at all times. Sometimes, however, the canal crosses a stream. During a heavy rain, that stream may overflow into the canal. To prevent this, most streams were redirected under the canal in culverts, like the one here at Jacob's Creek. The canal crossed over larger streams, such as Alexauken Creek, in an aqueduct.

In 1888, to create the city's first public park, Trenton acquired land along the feeder canal. Frederick Law Olmsted, noted landscape architect and designer of New York's Central Park, was hired to design the graceful grounds. Within the park is the 34-room Tuscan villa Ellarslie, built in 1848 as the summer home of a young Philadelphia lawyer. Ellarslie, now the museum of the city of Trenton, showcases the history and products of the once booming pottery industry in the capital.

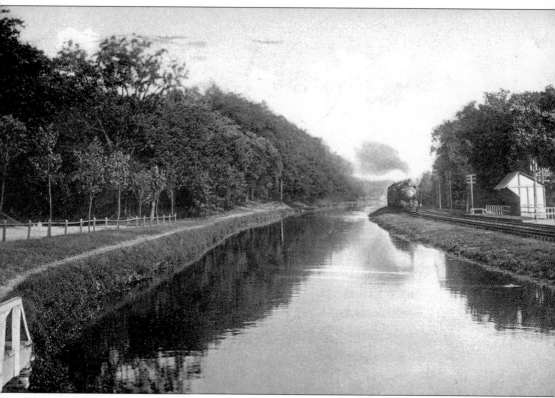

Mule-pulled boats were generally the rule on the feeder, as the six-foot depth was too shallow for most steam tugs. The white bridge (left foreground) at Cadwalader Park allowed the mules to cross an incoming stream. The Belvidere-Delaware engine is steaming north, near the little station. This was one of the last peaceful areas the boatmen saw before encountering the bustling, noisy industrial center of the capital city.

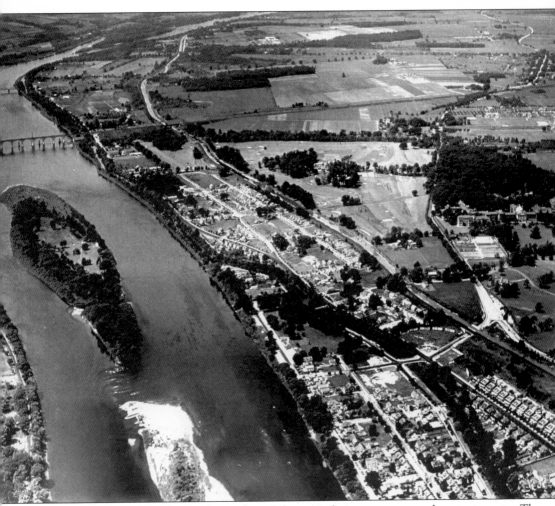

Looking north from the northern edge of the capital city, we can see three waterways. The Delaware River, spanned by the arched Reading Railroad bridge, is at the left. At the eastern end of that bridge we can see the narrow strip of water that is the Trenton Water Power Canal, which powered the industrial heart of the city. Farther inland, the Delaware and Raritan Canal feeder parallels the river on its way to the junction with the main canal.

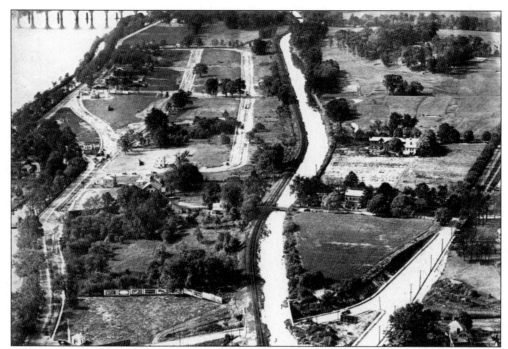

In this view looking north, the feeder flows through this more rural section of Trenton. The road passing from west to east, near the bottom of the picture, is Sullivan Way. The feeder crosses over Sullivan Way and the Trenton Junction trolley on an aqueduct.

The banks of the Parkside Avenue aqueduct were widened to accommodate the tracks of the Belvidere-Delaware Railroad. Seen from street level, the aqueduct is supported by a beautifully designed tunnel. This section of the towpath trail keeps today's visitors high above the bustle of the city and offers lovely, tree-lined vistas.

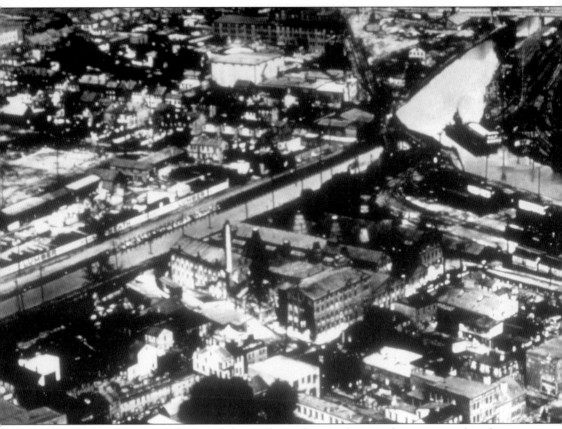

The feeder, flowing south (from left to right in this view), joins the main canal in downtown Trenton, near Old Rose Street. The steam tug heading toward New Brunswick is towing a boat through the open swing bridge of the Belvidere-Delaware Railroad. Today at this intersection, the water-filled feeder is visible, but the main canal flows in a conduit under Route 1 for about a mile. The canal returns to street level at Mulberry Street.

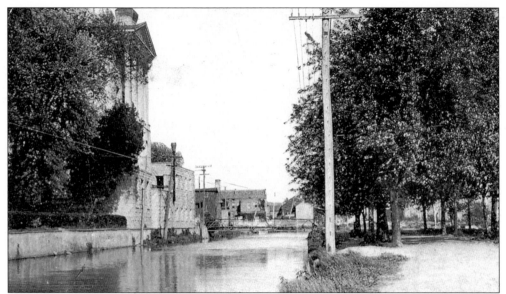

A sidelight to our tour of the Delaware and Raritan is the Trenton Water Power, a long-forgotten canal. Like the Delaware and Raritan, it was closely linked to the industrialization of the city. Built between 1831 and 1834 by the Trenton Delaware Falls Company, the water power drew its water from the Delaware River to supply power to new businesses in south Trenton and around the mouth of the Assunpink Creek. Beginning at Scudders Falls, and for most of its distance running parallel to the Delaware and Raritan, the water power continued for seven miles, feeding close to 20 mills and factories. It was abandoned and filled in during the early to mid-20th century, beginning at the downstream end. In the 1950s, the upstream section was filled in for the construction of Route 29.

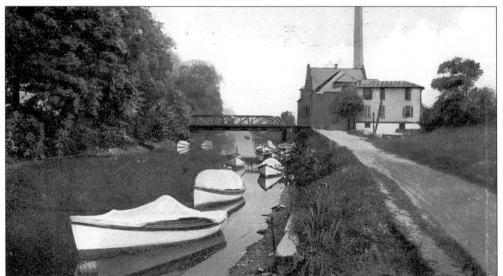

The Trenton Water Power followed approximately the course of today's Route 29. From the late 1840s, it was largely under the control of Cooper and Hewitt's Trenton Iron Company and this firm's various iron- and steel-making successors, all located at its downstream end in south Trenton. Unlike the Delaware and Raritan Canal, the Trenton Water Power was primarily a source of power and only secondarily used for transportation and pleasure boats.

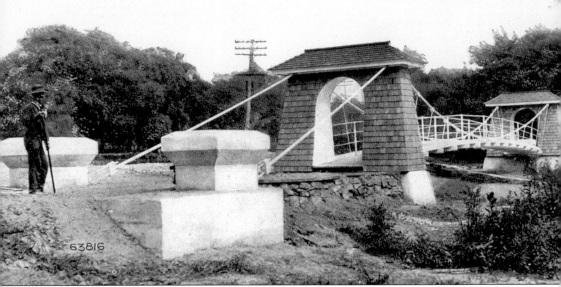

63816

Built by the Roebling company, this suspension bridge spans the creek that drains from the Perdicaris Waste Weir on the Delaware and Raritan. The Shakey Bridge, as it is sometimes called, opened to pedestrian traffic in 1908. The Roebling Works built the bridge for the city of Trenton at cost, in order to foster the effort to develop a park, today's Mahlon Stacy Park, along the water power. It is on the river side of the water power, just upstream of the Trenton Water Filtration Plant. The bridge was planned to be a smaller version of Roebling's Niagara River Bridge.

Six

WORK AND PLAY
ALONG THE WAY

John Philip Holland was born in Ireland in 1841. He taught school in Ireland until 1872 and in Paterson, New Jersey, until 1879 while drawing and perfecting plans for a submarine. On May 22, 1878, he launched his first submarine in the Passaic River, upstream of the Great Falls. It sank, but he raised it, made repairs, and successfully submerged it 14 days later. Holland then scuttled Boat No. 1, as he called it, to keep it a secret from his rivals. Twenty-two years later, he produced the more sophisticated *Holland VI* and took it to Washington for its navy trials. To avoid the Atlantic Ocean, Holland used the Delaware and Raritan for this trip. Due to the canal's shallow depth, the submarine cruised through on pontoons, as seen here.

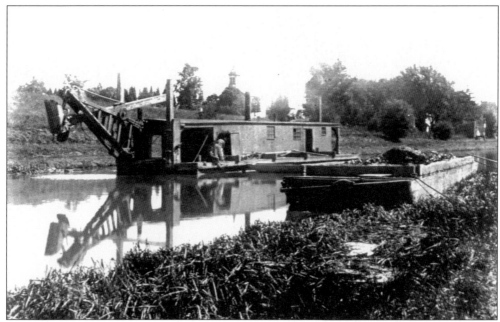

Then as now, rainstorms brought dirt and silt into the canal, making it too shallow to be efficient. Here, workers on a dredge are removing the silt to increase the depth and flow of the water. In this delicate operation, the men must take care not to break into the clay lining the bottom of the waterway.

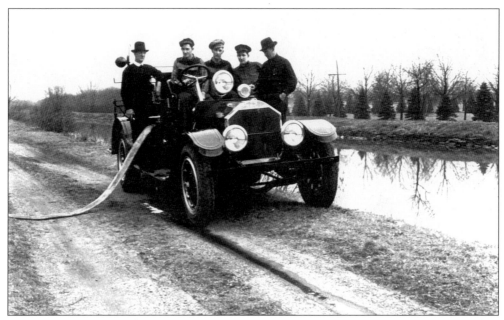

Fire was an ever-present danger in the 19th century. Towns located along the canal, however, had a great advantage when fire struck. Firefighters could quickly pump unlimited quantities of water onto the burning structures. These gentlemen have driven the pumper to the very edge of the towpath to practice for the next fire. The suction hose is no doubt dangling in the water, but the men are blocking our view of the pumping engine. Also, this photograph appears to be reversed.

In the days before electric refrigeration, foods were kept cold by using ice cut from rivers, lakes, and canals. Since the canal was partially drained in the winter, it was safer than the river for ice harvesting. The quiet water of the canal froze deeper, making for thicker ice. The men are using a horse-drawn saw to score the ice into blocks. Handsaws were also used to cut the ice into two- by three-foot cakes.

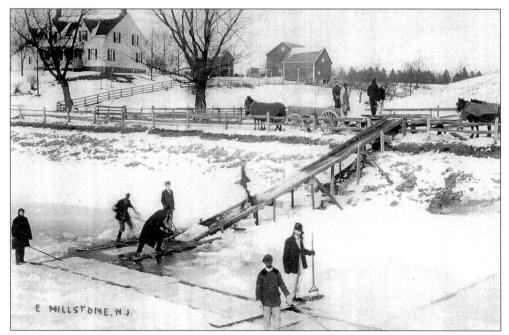

After creating a channel, the men use long poles called pikes to move the blocks of ice toward the wooden chute. The blocks are guided onto the chute and pushed or pulled up to the wagons. Ice was stored in an icehouse and covered with straw or sawdust to delay melting. If properly constructed, an icehouse could retain 70 percent of the ice volume over a one-year period.

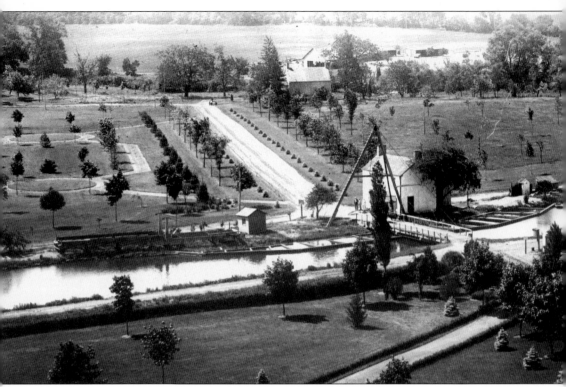

In this view looking east at Zarephath, the A-frame bridge crossing the canal is about to be replaced by a king-post bridge. The new bridge is resting on the berm bank, just to the left of the bridgetender's hut. The center posts of the span can be seen in the middle of the structure. The king post (as seen in the close-up on page 27) was stronger, able to accommodate the heavier cars and trucks of the early 20th century.

In 1861, at the onset of the Civil War, 14 Delaware and Raritan Canal Company steam canalboats carried 3,000 troops and equipment to the defense of Washington, D.C. During World War I, the government used the canal for safe transport of boilers and other naval supplies between the navy yards at Brooklyn and Philadelphia, and again to Washington, D.C. Here, U.S. Navy Submarine Chaser No. 252 is tied up, probably waiting to lock through.

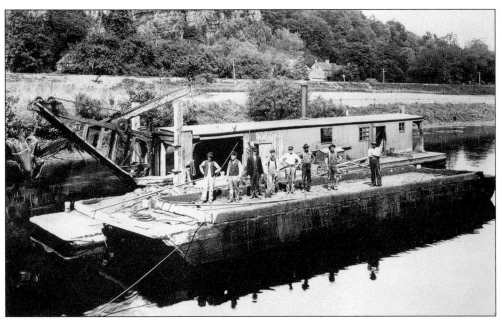

These gentlemen will help us to segue from work to play on the canal. They stand upon their canal company work scow, which is tied up next to a dredge. They look ready and able to repair a bridge or fix a spillway. They are, however, not working but taking a break to pose for a passing photographer.

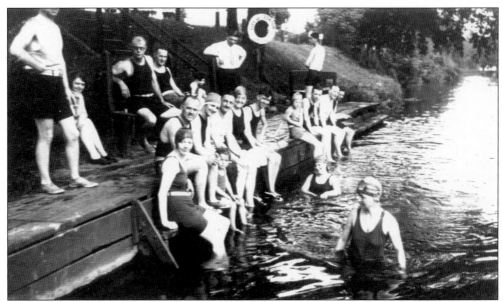

In Cadwalader Park in Trenton, young people enjoy the cool waters of the feeder canal. The dock and stairs made it convenient to access the canal on those warm summer days.

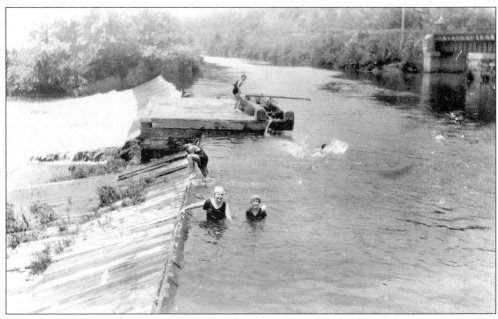

In Prallsville, where the Wichecheoke Creek flows directly into the Delaware and Raritan Canal, swimmers enjoy a cool break from the summer's heat. The creek enters the canal under the railroad bridge on the right. The overflow then spills directly into the Delaware River, over the wood-sheathed dam, or waste weir.

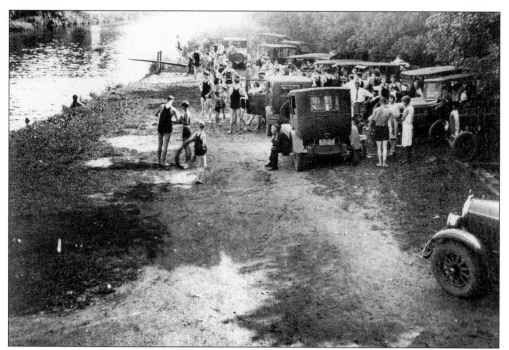

On a warm Sunday afternoon in Griggstown, the Delaware and Raritan Canal is a popular spot. Some folks are just arriving from church, while most have already donned their fashionable swimwear. This view looks downstream from the king-post bridge.

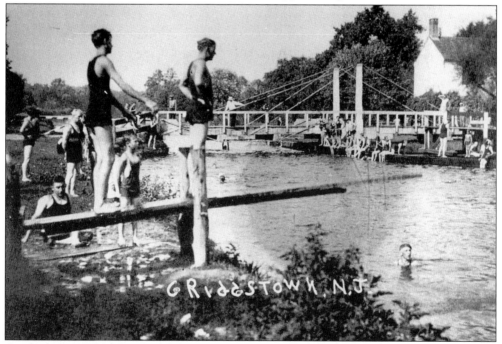

On the homemade diving board (seen in the distance in the previous view), two daring young men are about to join their friends in the cool water of the canal. The king-post bridge, just downstream, provides a great viewing platform.

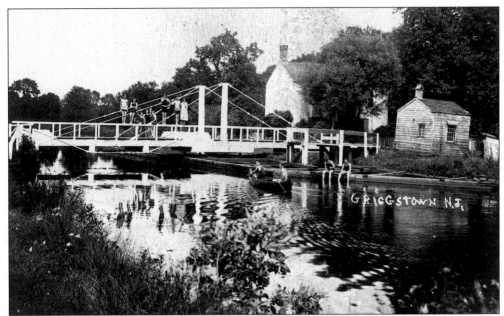

This full view of the king-post bridge includes the bridgetender's hut, looking uncared for, on the right. The young people getting ready to dive are reflected in the water. On the east side of the bridge, the young men are sitting on the fenders that protected the bridge from misguided boats.

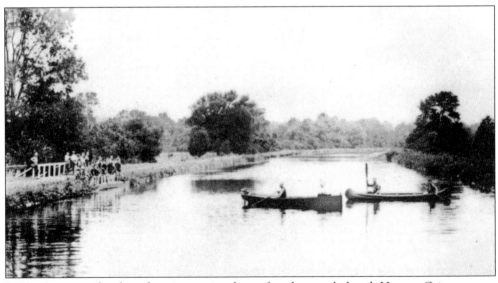

Boating continued to be a favorite pastime long after the canal closed. Here at Griggstown, a canoe and a motorboat are the center of attention for the crowds gathered on the towpath. Today, because of the rules set forth by the New Jersey Water Supply Authority, boating is limited to paddled and electric-powered craft. Some suggest, however, that we take a tip from our friends in the United Kingdom. Recreational boating on their canals (which are also used for potable water) provides an economic boom to the entire nation.

These well-dressed folks have paddled in toward the towpath, perhaps to greet friends. Or perhaps they will tie up to the tree and stroll into the village. As befits the era, they are covered from head to foot, not at all like our summertime garb of today. Note, too, the interesting variety of hats.

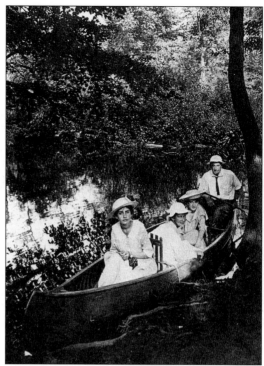

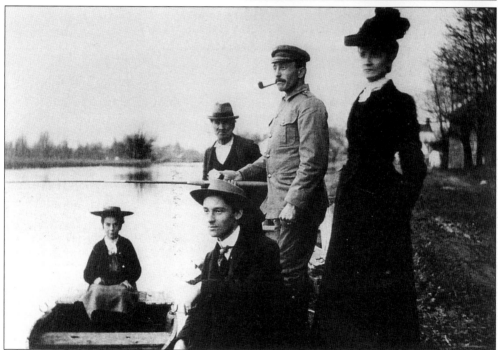

Even more formally dressed are these members of the Rightmire family, longtime residents along the canal in Griggstown. The pipe-smoking gentleman is fishing, still a very popular canal activity today. The other three may have just arrived in the boat with their lady friend, or they may be leaving. Note the distinctive headwear.

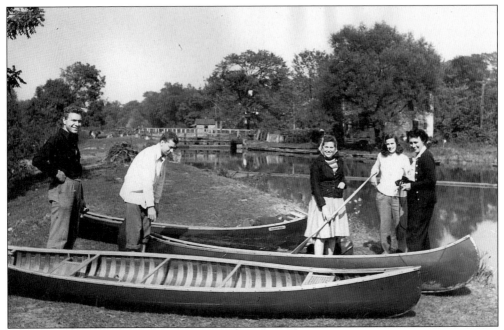

In a more modern photograph, these young adults have just portaged their canoes from the Millstone River and are about to launch into the canal. For a circular trip, boaters sometimes paddle down the Millstone River, portage to the canal, and return upstream on its gentler waters. Although the canal is basically level, there is a current, so paddling upstream still takes a bit more effort than going downstream.

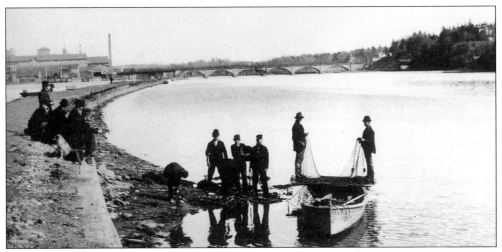

In New Brunswick, too, fishing was a popular pastime. These shad fishermen are about to toss their nets into the Raritan River, about halfway between the Albany Street bridge in the distance and the outlet locks. Their friends are sitting on the towpath, with the canal behind them.

In the winter, the canal was partially drained, making it a much safer playground than the nearby rivers. Sledding and skating were popular pastimes. The Rightmire family lived near the Griggstown lock and had ample opportunity to photograph activities on the canal. Here, Mary Rightmire has recruited her dog to pull the sled along the frozen canal. The second pooch gets a free ride.

Because the canal was partially drained in the winter, skating was safer there than on a river. This photograph, however, was taken long after the canal had ceased operation. Between locks and bridges, one could often enjoy a skate of several miles without an obstacle.

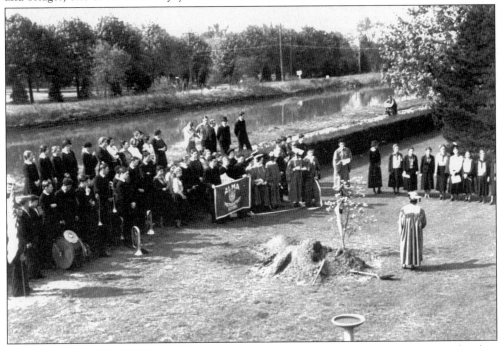

The canal affords a lovely backdrop for graduation at the Alma White Preparatory School in Zarephath. A tree-planting ceremony marks this special occasion. The towpath is on an embankment here, making it a splendid spot for seeing over the heads of the graduates.

Seven

THE END . . . AND REBIRTH

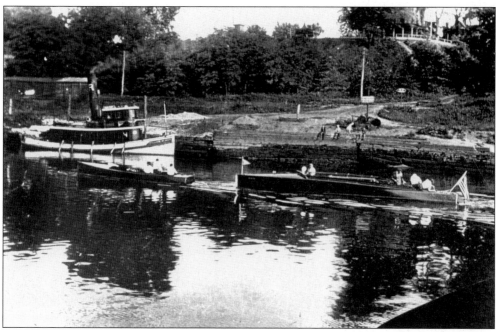

In the 1920s, when commercial traffic had slowed to a trickle, gasoline-powered yachts replaced canalboats and freight vessels on the waterway. Although the canal was in decline, pleasure boat traffic nearly doubled. Private boat owners continued using the canal as an essential link between two major centers of pleasure boating, Long Island Sound and the Chesapeake Bay, because it cut off nearly 200 miles from the more hazardous ocean route around Cape May. In the autumn, yachts sailed from northern harbors to Perth Amboy and up the Raritan River to New Brunswick. Here, they entered the canal through the outlet locks, paid the toll, and received a permit for passage. In 1929, the peak year for noncommercial vessels, 941 pleasure boats transited the waterway. Taken from Lock No. 1, this photograph shows one motor launch being towed by another as they pass a steam tugboat tied up on the left. The bluff in Bordentown is seen in the distance.

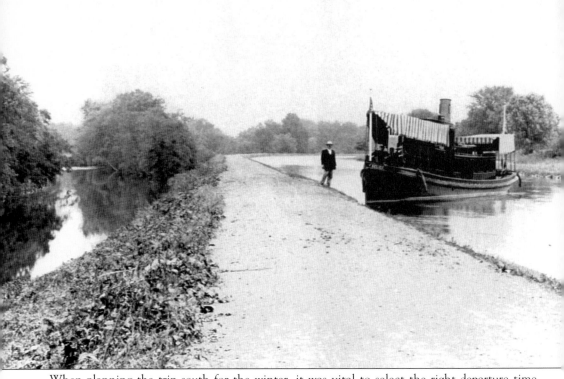

When planning the trip south for the winter, it was vital to select the right departure time. Around the turn of the century, the 28-foot sailboat *Lotus* departed from New York on Thanksgiving Day. After dodging ice floes in the Raritan River, the crew disembarked in New Brunswick to inspect the lock and canal, which "as far as one could see were solid full of broken up ice." The mule team and driver engaged in New Brunswick for a tow through the waterway were not equal to the task, so the icebreaker tug *Relief* (pictured) agreed to assist by towing the craft for a portion of the journey. Ice fenders were constructed to protect the *Lotus*. After tying up for the night, the vessel found itself frozen solid in ice; manpower and heavy spars were required to free the craft. Periodically, the tug dropped its towline and went ahead alone to break up the ice. It then returned to the *Lotus* to resume the tow. This was no doubt the last journey of that season before the canal was closed and drained for the winter.

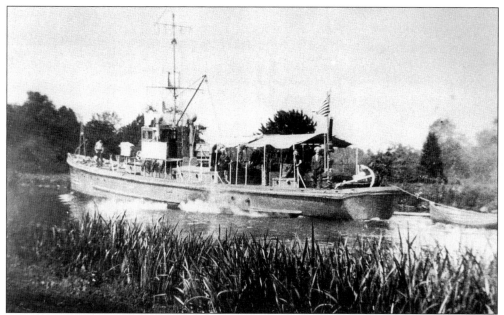

As freight traffic on the canal dwindled, the pleasure boaters petitioned the state to keep the canal open. Unfortunately, the tolls from these private boats were not sufficient to overcome the loss of freight traffic. In the winter of 1932–1933, the canal closed as usual but did not reopen in the spring of 1933. The original charter to the Joint Companies called for forfeiture to the state if the canal failed to operate for three consecutive years. As a result, in 1937, the Delaware and Raritan Canal became the property of the state of New Jersey.

Throughout the 1930s and 1940s, the canal was used informally for recreation, such as swimming and canoeing. As industries began to move out of the cities in the late 1930s, they often chose sites near the canal due to the excellent rail and road connections and the source of cheap water. As a result, the Delaware and Raritan, which could no longer make a profit by transporting cargo *on* its water, began to make a profit from the sale of the water itself.

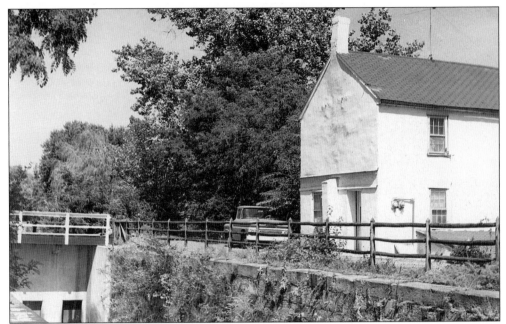

Rehabilitation of the main canal and the feeder began in 1944 under the Division of Water Resources. To convert the waterway to a water supply system, the division removed the lock gates and constructed sluices and dams, as seen here at the lock in Lambertville, on the feeder. These structures are used to control the amount of water released downstream.

In 1936, the prism of the main canal south of the junction in Trenton was filled in as a project of the Works Progress Administration. Within the walls of Lock No. 7, heavy equipment has removed the timber foundations that supported the masonry lock. Much of this filled-in canal right-of-way was unused until Route 129 was built between the Northeast Corridor rail line and the Lalor Street area.

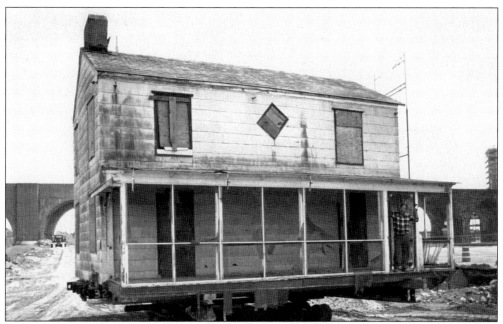

When plans were made to construct state Route 18 through New Brunswick, it was decided to fill in Lock No. 13, Deep Lock. At the same time, the locktender's house would be moved to Lock No. 14, the outlet in Boyd Park. Here we see the structure being moved to its new site; Bob Nolan, who worked for the Water Supply Authority for more than 30 years, is standing on the porch. The house was to become a museum but was destroyed by the city of New Brunswick in violation of the memorandum of understanding that it had signed.

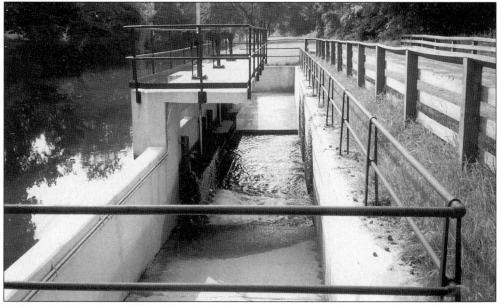

Today, the New Jersey Water Supply Authority maintains and operates the canal as a water supply facility. The authority maintains and repairs the culverts, locks, aqueducts, spillways (pictured), and other structures to ensure a reliable flow of water to its customers. About a million people in central New Jersey have some amount of canal water in their daily supply.

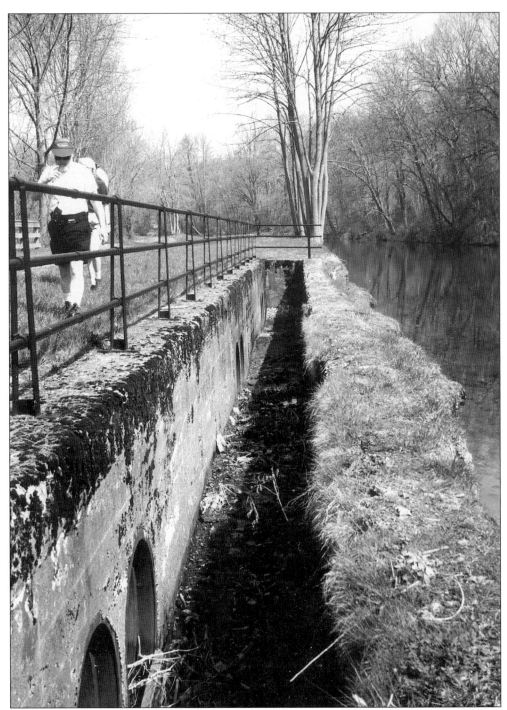

Here is another type of spillway, or waste weir, found along the canal. Excess water from heavy rains or flooding spills from the canal over the grass-covered weir. It then flows through the pipes (bottom left) and into a nearby stream that feeds the Delaware River. These visitors are among the hundreds of thousands who use the canal towpath, a very popular greenway for walkers and bicyclists in central New Jersey.

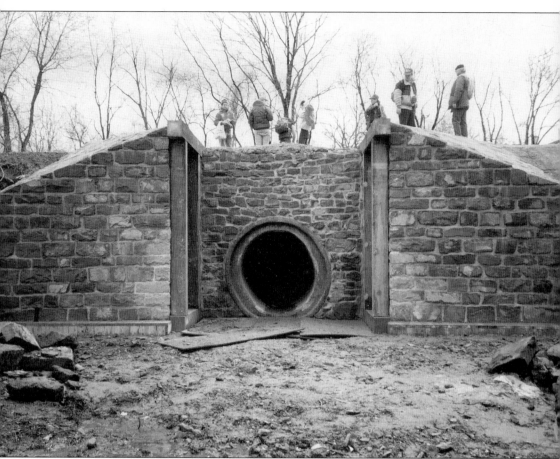

In 1989, the New Jersey Water Supply Authority repaired this culvert near the Griggstown lock. The large pipe carries the overflow from the Griggstown lock bypass into a nearby stream that feeds into the Millstone River. For this construction project, the canal was partially drained, revealing the clay liner at the bottom of the prism. (The prism is the interior shape of the canal—sloped sides and flat bottom.) The structure is actually reinforced concrete, with a native stone veneer to preserve the historic character of the Delaware and Raritan Canal.

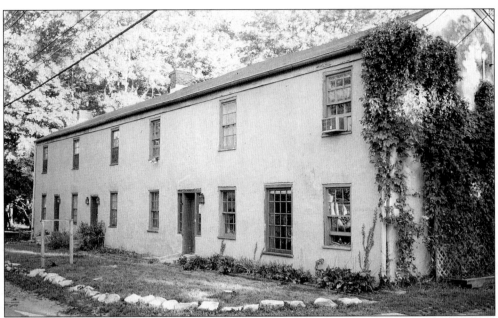

In 1973, the Delaware and Raritan Canal and 17 related structures were placed on the National Register of Historic Places. A year later, in response to pressure from concerned citizens, the New Jersey legislature passed an act creating the Delaware and Raritan Canal State Park. The park is owned and operated by the Division of Parks and Forestry, Department of Environmental Protection. The Griggstown Long House (pictured), formerly known as the Mule Tenders Barracks, is one of the historic buildings in the park.

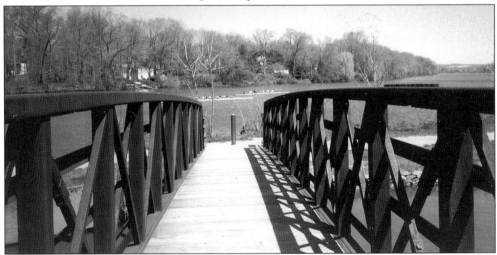

One task of the Delaware and Raritan Canal Commission is to prepare and adopt a master plan for the physical development of the park. Over the years, the commission, under the outstanding leadership of Jim Amon and in cooperation with the Division of Parks and Forestry, has championed many improvements in the park. Here, for example, a pedestrian bridge was installed across the canal at the Millstone Aqueduct, allowing visitors to access the towpath. A new path was created on the east side of the canal in this area, providing a delightful circular walk for local residents. In the distance, rowing teams from Princeton University are practicing on Lake Carnegie.

Nearly 36 miles of the main canal and 22 miles of the feeder canal remain intact. The historic towpath is open for recreation from Mulberry Street in Trenton to Landing Lane in New Brunswick, and from the junction in Trenton to Bulls Island. The northern terminus in Boyd Park, in New Brunswick, while not a part of the state park, features the restored outlet locks, towpath, and interpretive signage. Visitors can hike, jog, canoe, ride horses, cross-country ski, bike, fish, or just walk the dog in this scenic greenway.

Several volunteer groups support the work of the Delaware and Raritan Canal State Park. The Canal Society of New Jersey sponsors walks and tours, while the D & R Canal Watch, through its annual 5K Run (pictured), raises funds for park projects. Historical societies along the waterway hold festivals, canoe races, and other events to highlight the canal's history and recreational value. Today, the historic Delaware and Raritan Canal and this truly special park provide much needed open space for the citizens of central New Jersey. Everyone can join the crowd and enjoy the Delaware and Raritan Canal, a tranquil ribbon of green that connects the Delaware Valley with the foothills of the Watchungs and gives modern New Jerseyans a sense of their 19th-century heritage.

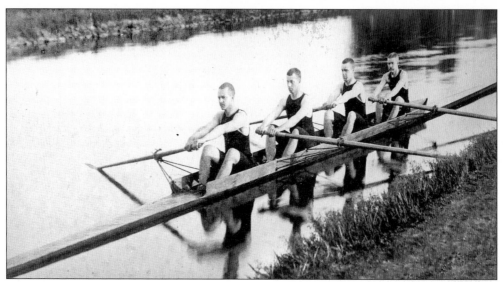

The rowing teams from Princeton University originally practiced in the Delaware and Raritan Canal. By 1886, however, traffic in the canal had made it too dangerous, and the rowing club was disbanded. On a 1902 visit to the university, Andrew Carnegie learned of the students' desire for a lake in which to row. He decided to support the project of damming the Millstone River to create a lake.

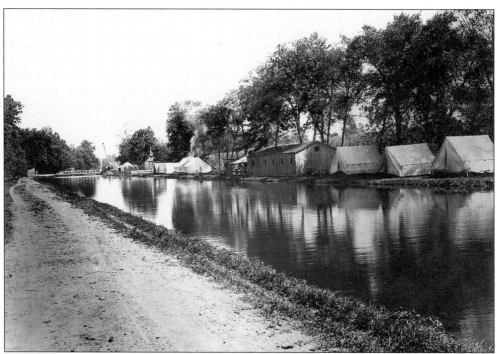

Construction of the lake began in 1904, and the workers lived in tents along the canal. In *The Story of Princeton*, Mark Norris writes that Carnegie "generously agreed to bear the expense, and after two years of excavating and construction, the huge engineering feat was accomplished." Subsequently, the lake was named for Carnegie.